T0160628

LIFE STUDIES LIFE STORIES

80 *Works on Paper*

FERLINGHETTI

CITY LIGHTS BOOKS
SAN FRANCISCO

GEORGE KREVSKY GALLERY

Cover painting: "Prague Through the Centuries"
Book and cover design: Stefan Gutermuth
Printed in China

Cataloging-in-Publication Data
Ferlinghetti, Lawrence.
 Life studies, life stories : drawings / by Lawrence Ferlinghetti.
 p. cm.
 ISBN: 0-87286-421-9
Ferlinghetti, Lawrence—Catalogs. 2. Nude in art—Catalogs. I. Title.

NC139.F42 A4 2003
741.973 –dc21 2002041268

Ferlinghetti is represented by the George Krevsky Gallery,
77 Geary Street, San Francisco, California 94108. gkg2othc@aol.com
The gallery will be mounting a show based on the contents of this volume in early 2004.

CITY LIGHTS BOOKS are edited by Lawrence Ferlinghetti and Nancy J. Peters
 and published at the City Lights Bookstore, 261 Columbus Avenue, San Francisco CA 94133.
 www.citylights.com

FOREWORD

As a painter, I have always been more interested in the life stories of models than in their physical appearance, and these drawings are all attempts to at least "scratch the surface" of the human façade.

Whether or not such a thing is at all possible in drawing from life, I hope my empathy for the subjects does shine through in these studies on paper chosen from more than 1,500 done over the years at various locations from the San Francisco Art Institute's open studios to my studio, in the Hunter's Point Shipyard, San Francisco.

I have always identified with my generation of painters – particularly the New York abstract expressionists Kline, deKooning and Motherwell – as well as Larry Rivers and Ron Kitaj. As with them, I feel that a certain mastery of drawing from life is relevant to the most non-objective painting.

My paintings on canvas, always wavering between the pure figurative and an emotive expressionism, have been done with a kind of "passionate intensity" plus at times a kind of lightness. And I hope the same is evident in these works on paper.

— L.F.

LIFE
STUDIES
LIFE
STORIES

After Nathan Oliveira. 1993. Oil, 15" X 22"

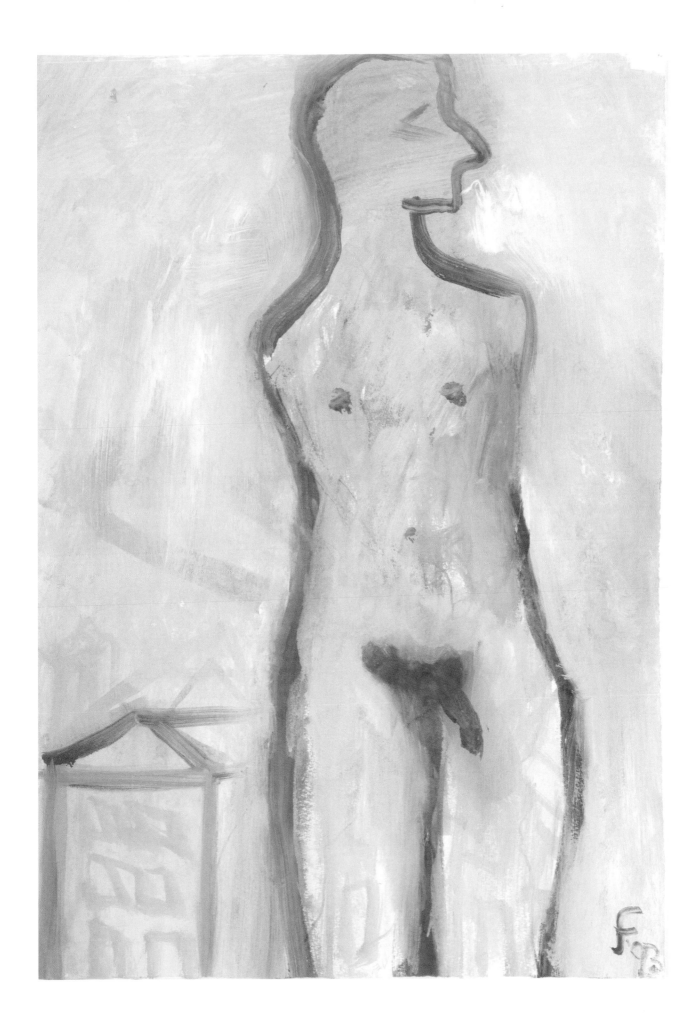

AFTER NERI. 2002. Oil, 22½" X 30"

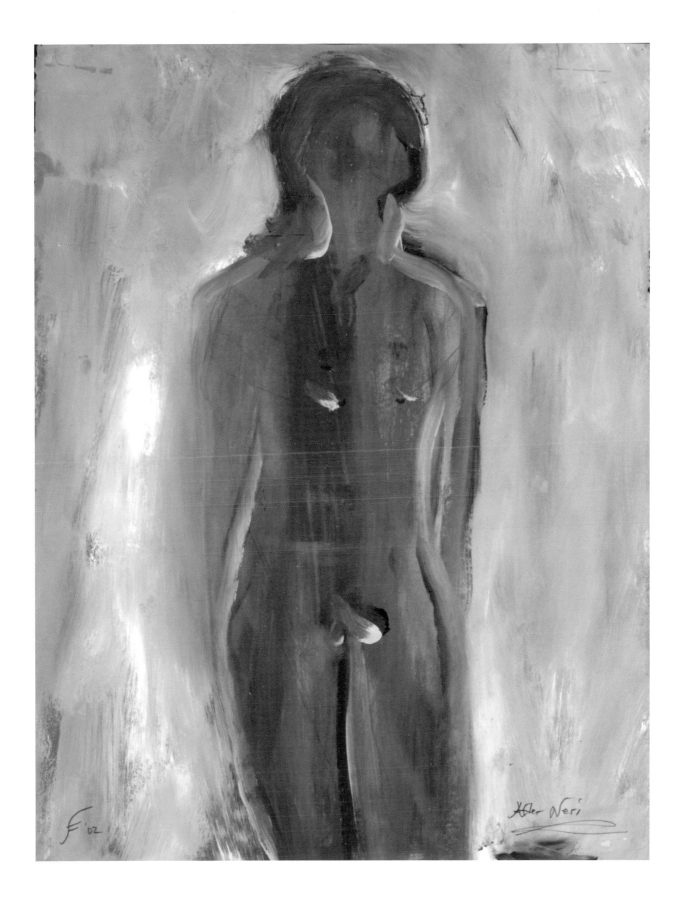

THE RED HEAD. 1998. Monoprint, 18" X 24½"

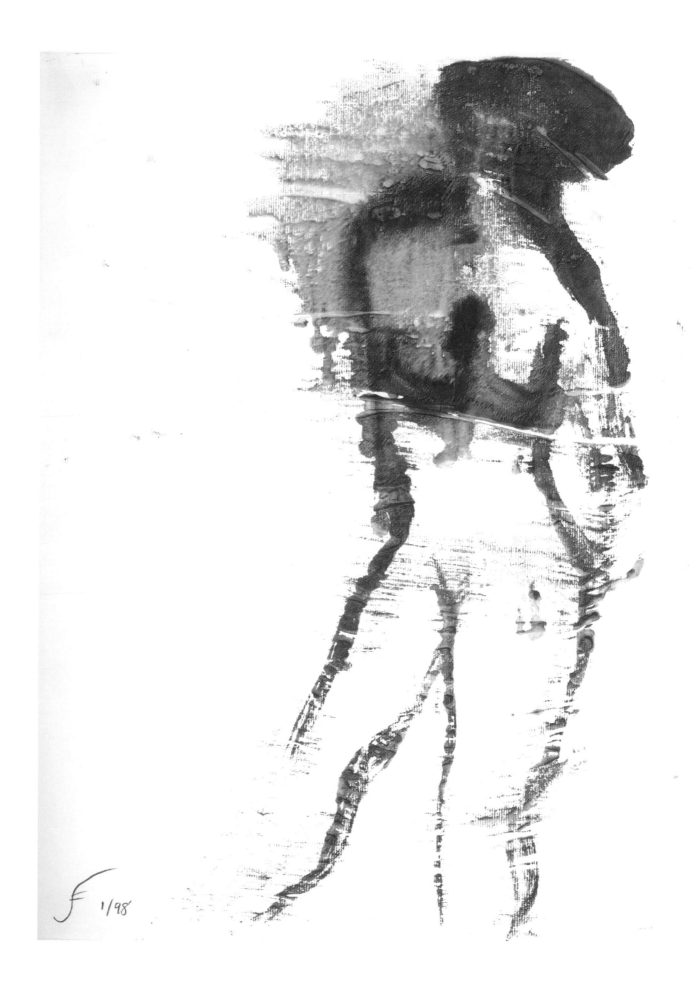

F 1/98

IN A RED QUANDARY. 1998. Monoprint, 18¼" X 24¼"

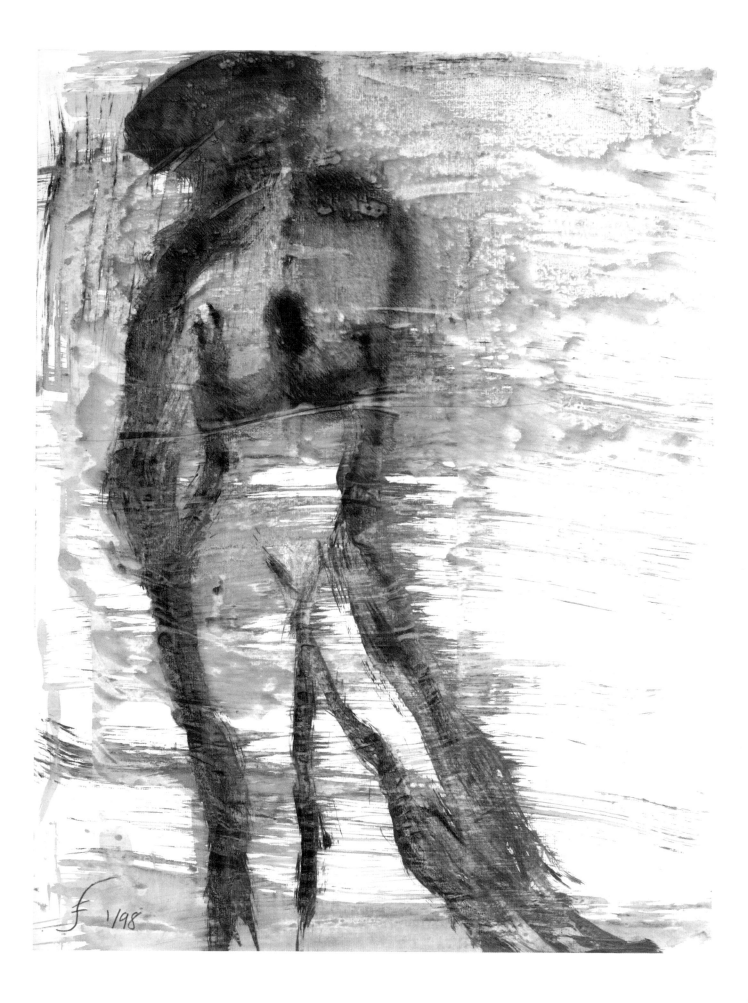

F 1/98

Wanting to Fly. 1991. Acrylic, 28¼" X 22"

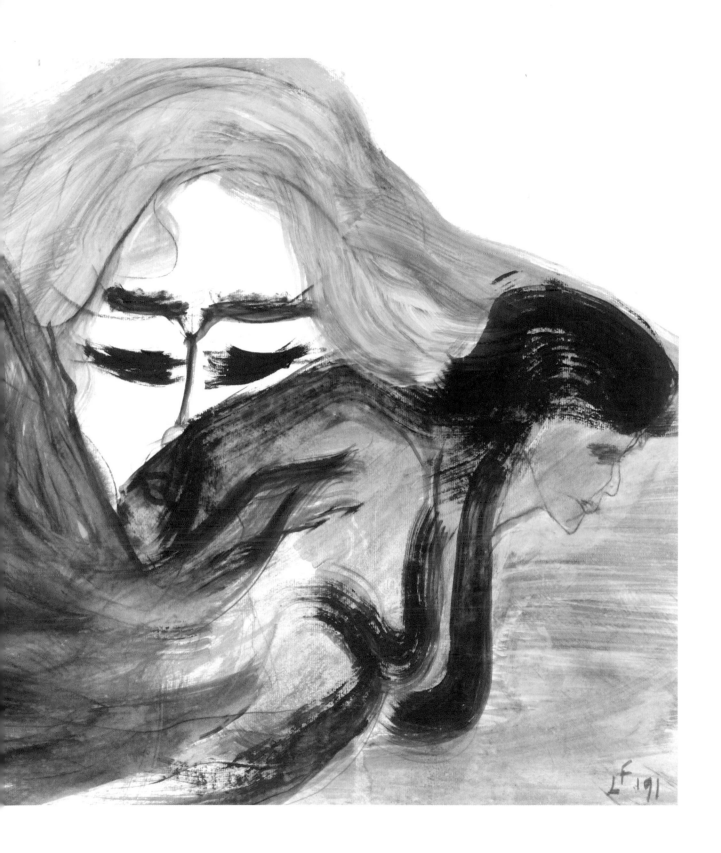

IN HER DARK PERIOD. 1983. Acrylic, 20" X 26"

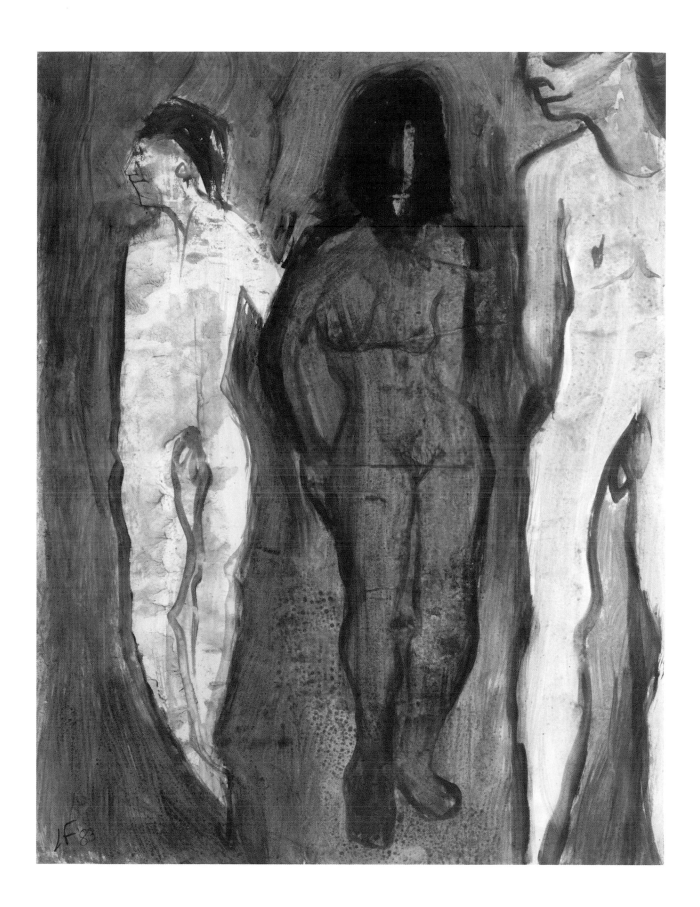

They're Together. 1999. Oil, 20" X 24"

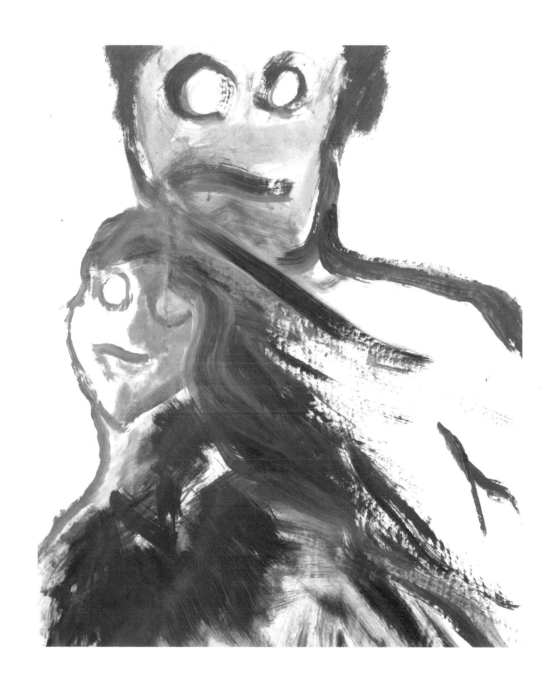

PREOCCUPATIONS. 1982. Ink, 15" X 17½"

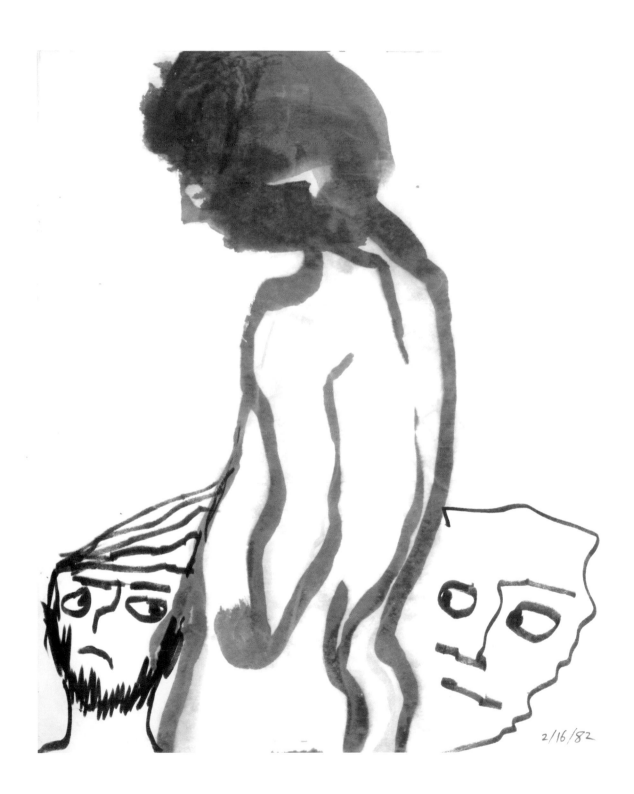

2/16/82

THINKING IT OVER. 1979. Acrylic and Charcoal, 21½" X 30"

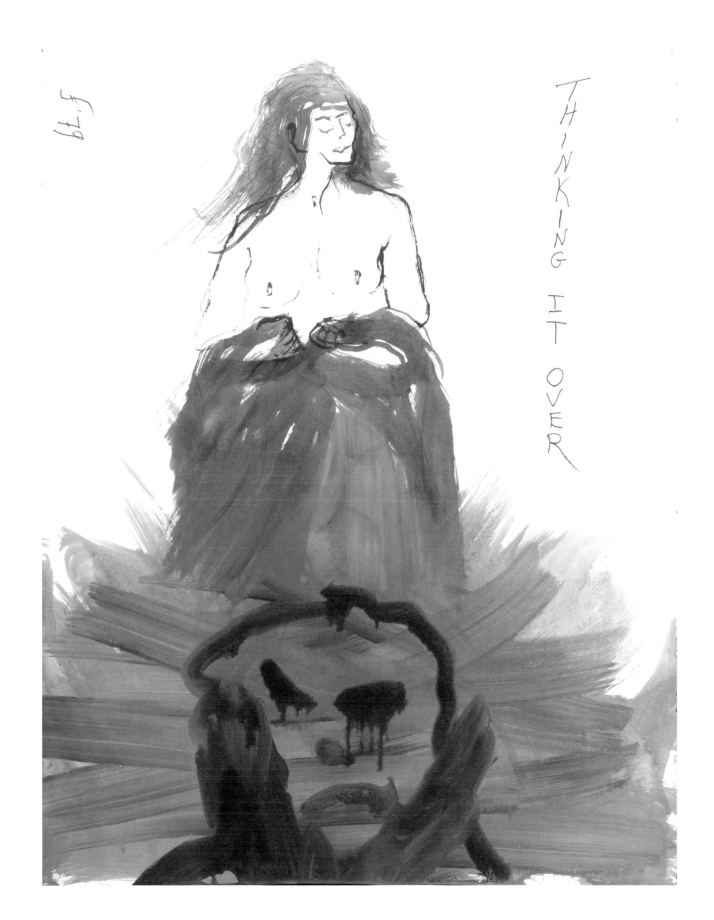

Fig. 79

THINKING IT OVER

THE PRISONER. 1999. Oil, 22" X 30"

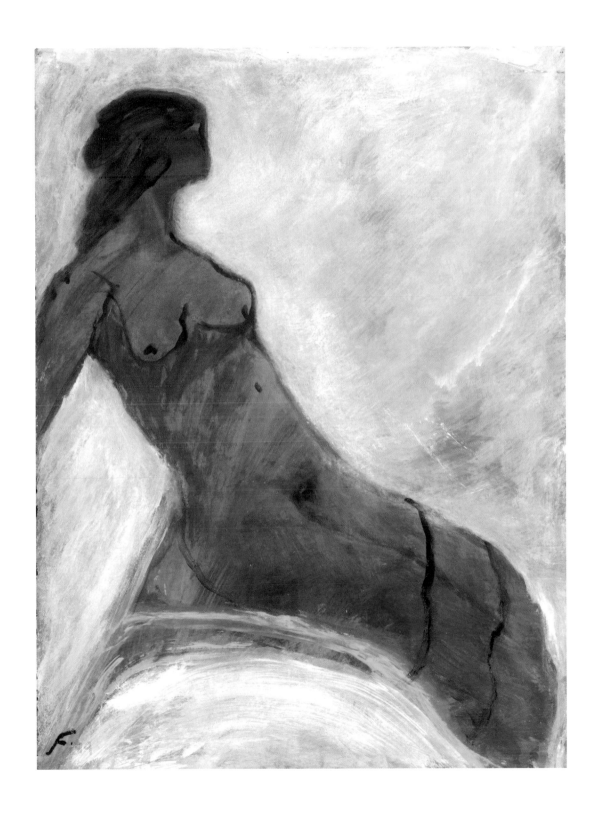

THEY HAVE A HISTORY. 1991. Acrylic, 23" X 29½"

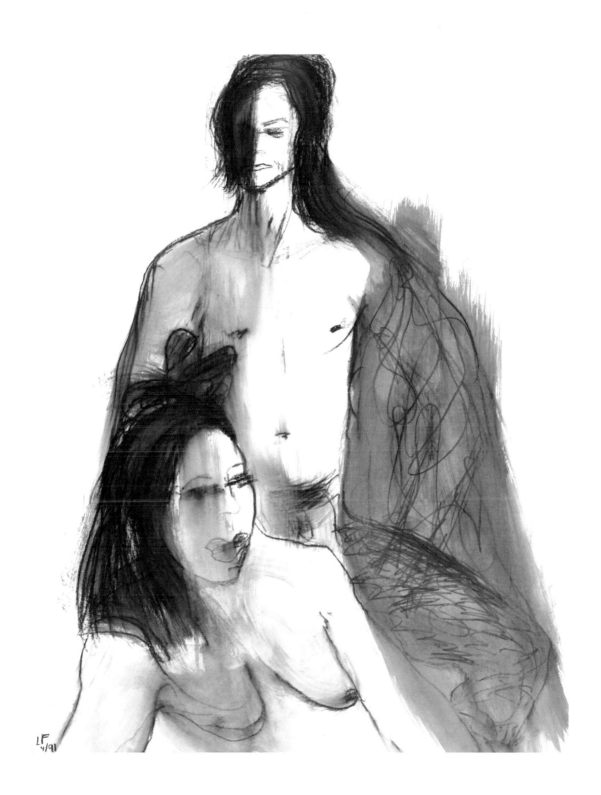

ALTER EGO? 1998. Crayon, 23" X 28¼"

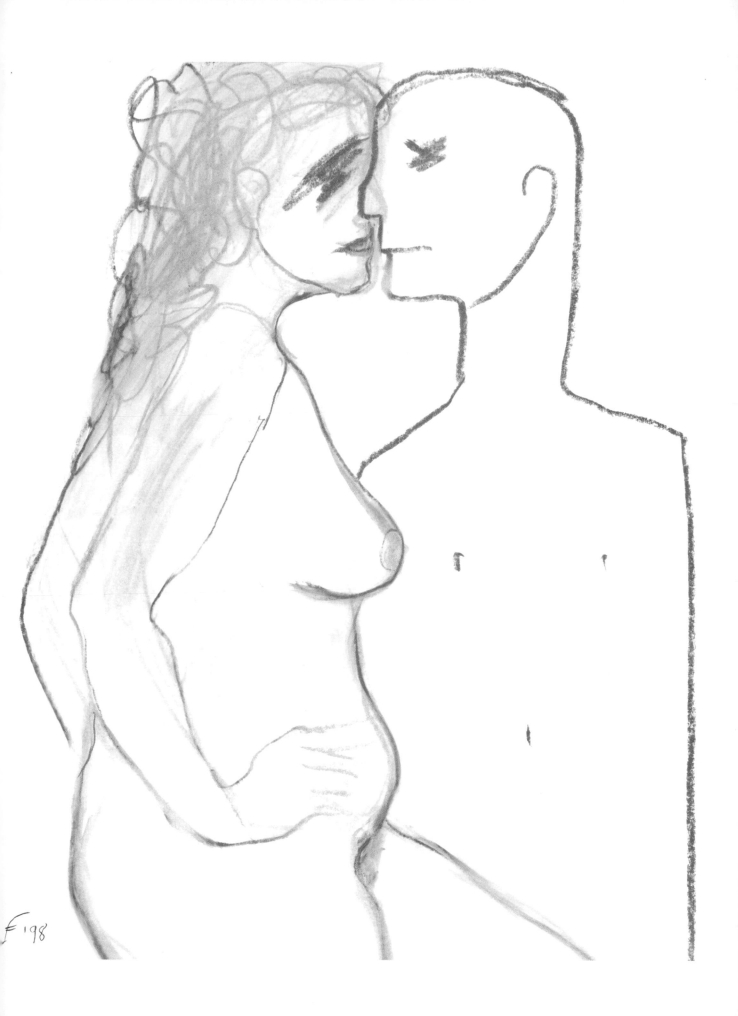

TAMING THE HORSE. 1991. Acrylic, 23¼" X 30"

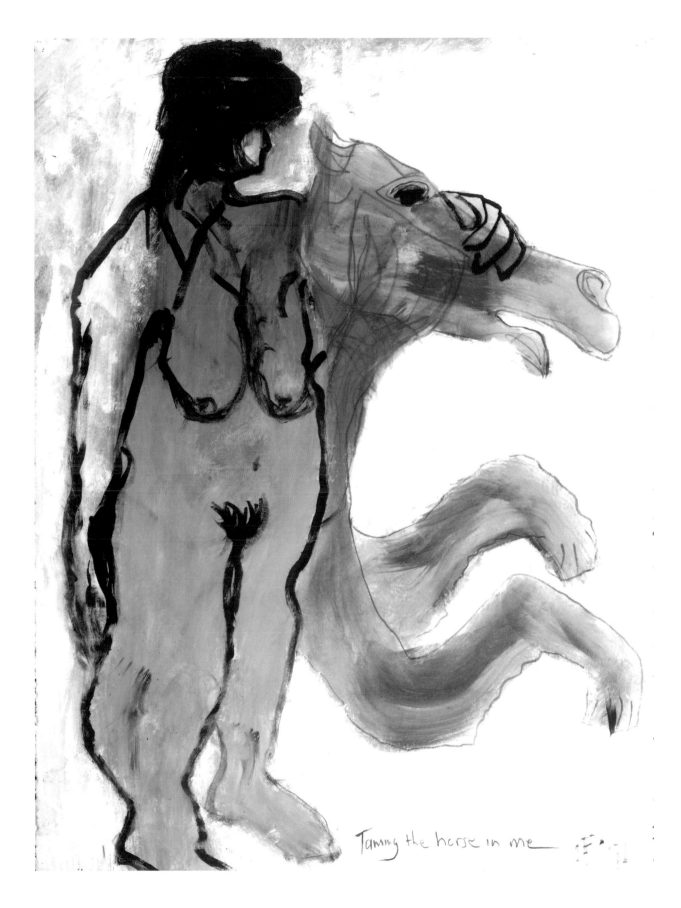

Taming the horse in me

THE NIGHT BEFORE THINKING. 1990. Oil and Charcoal, 18" X 23¾"

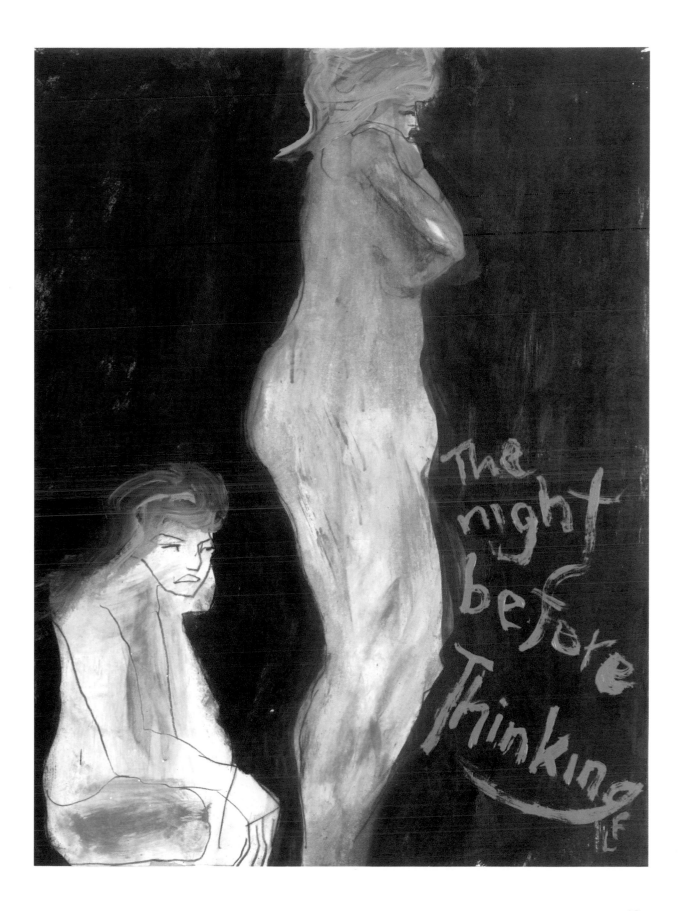

The night before Thinking LF

PUTTING UP A SMOKESCREEN. 1984. Acrylic, 23" X 28½"

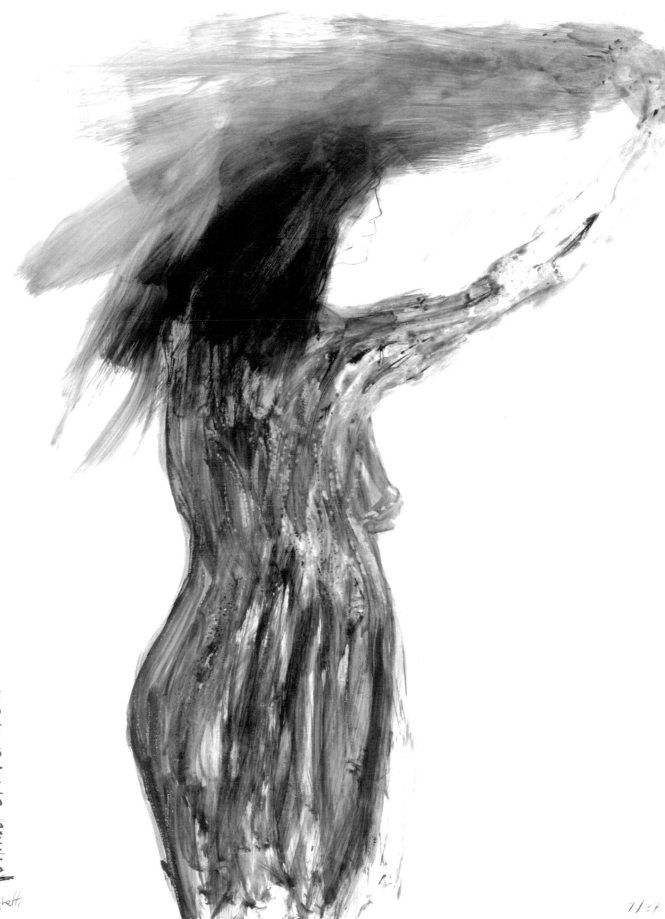

PUTTING UP A SMOKESCREEN

Ferlinghetti 7/34

UNDER A CLOUD. 1990. Acrylic, 18" X 24"

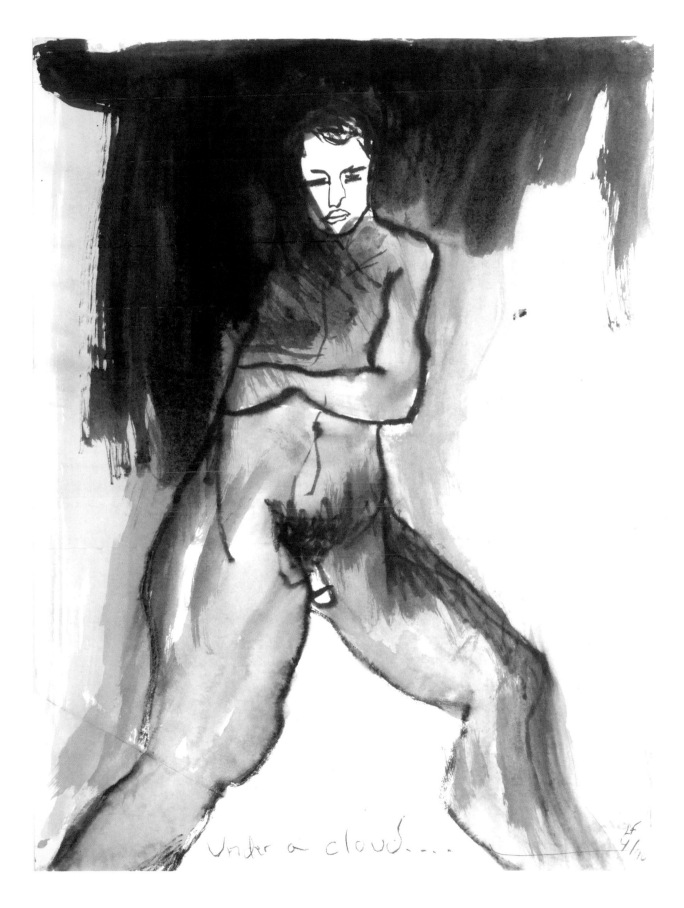

Under a cloud....

KEEPING HIM. 1993. Acrylic and Ink, 15" X 22"

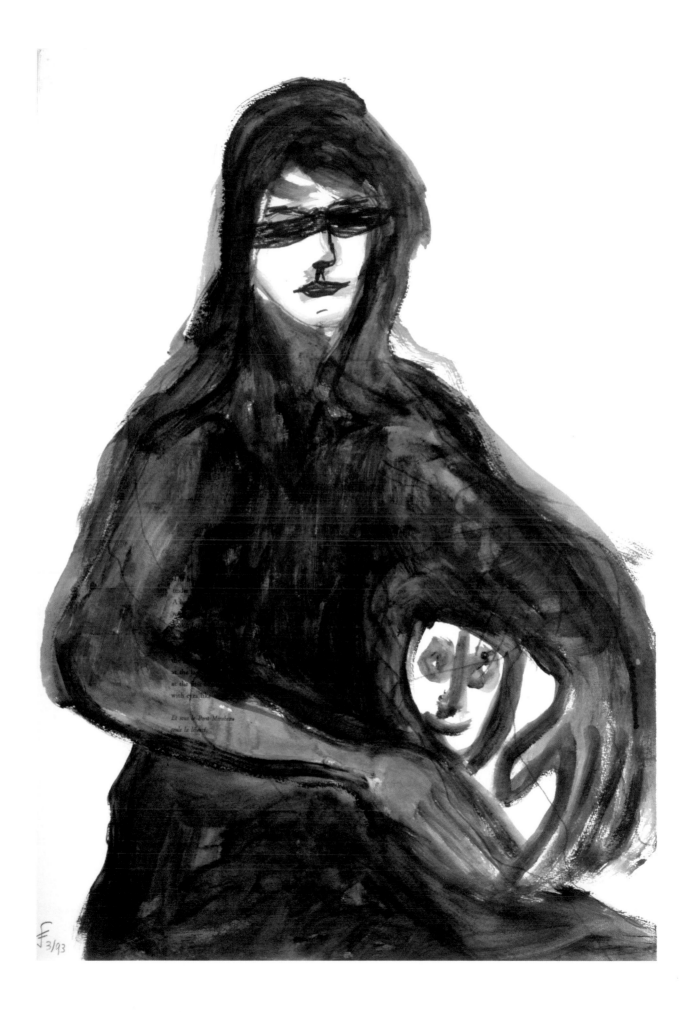

The Cloud of Unknowing. 1984. Acrylic and Charcoal, 23½" X 29½"

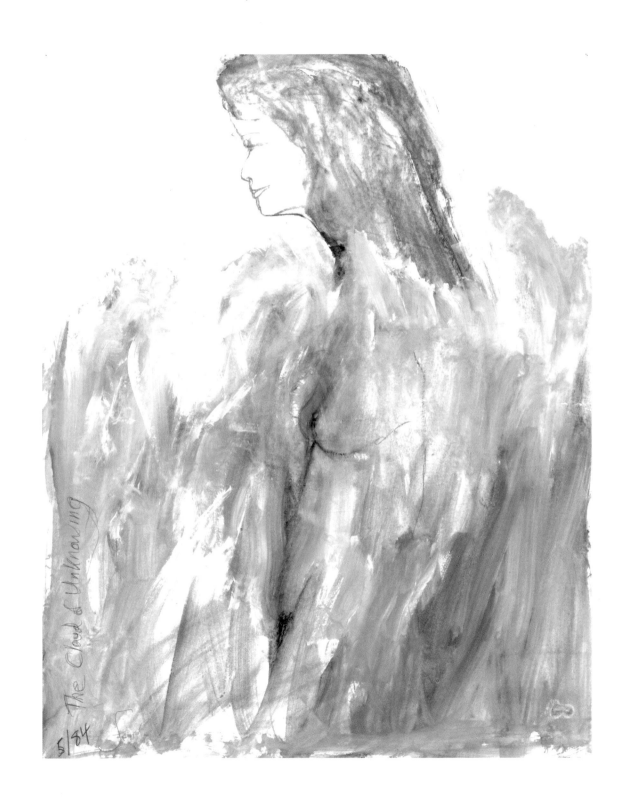

The Cloud of Unknowing

5/84

THE HEARTLESS ONE. 1984. Acrylic and Charcoal, 22½" X 29½"

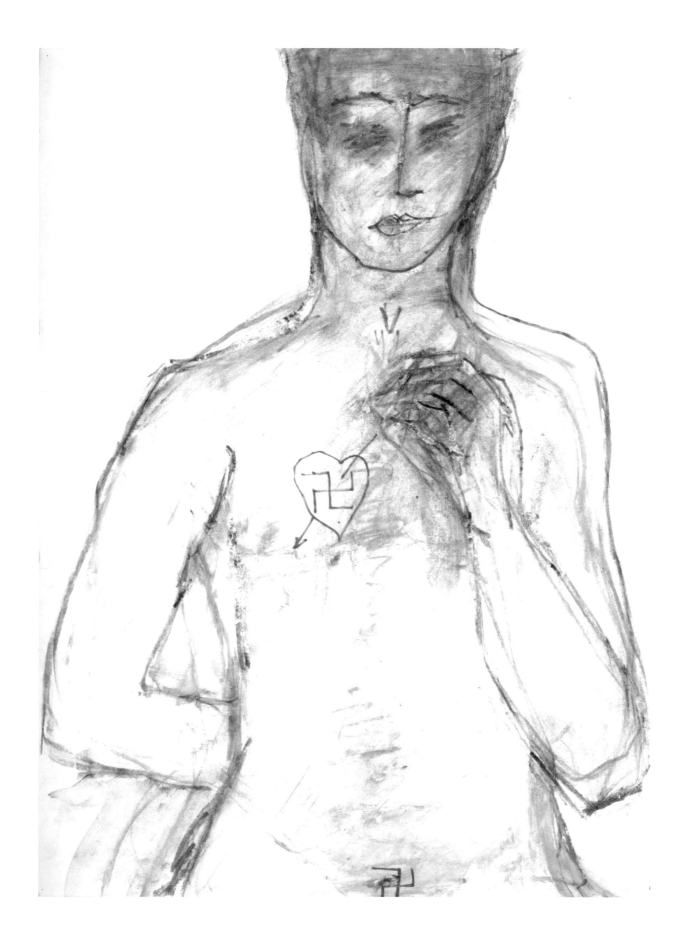

MADONNA IN A BOX. 1995. Oil, 24" X 30"

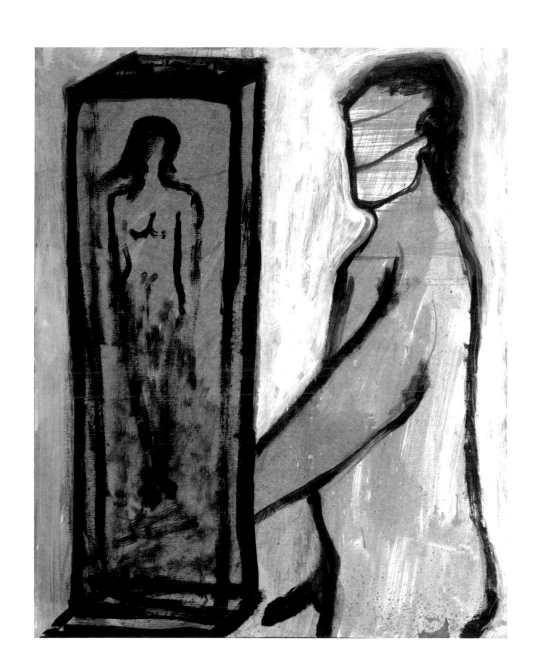

A Blue Story. 1990. Acrylic, 23" X 27"

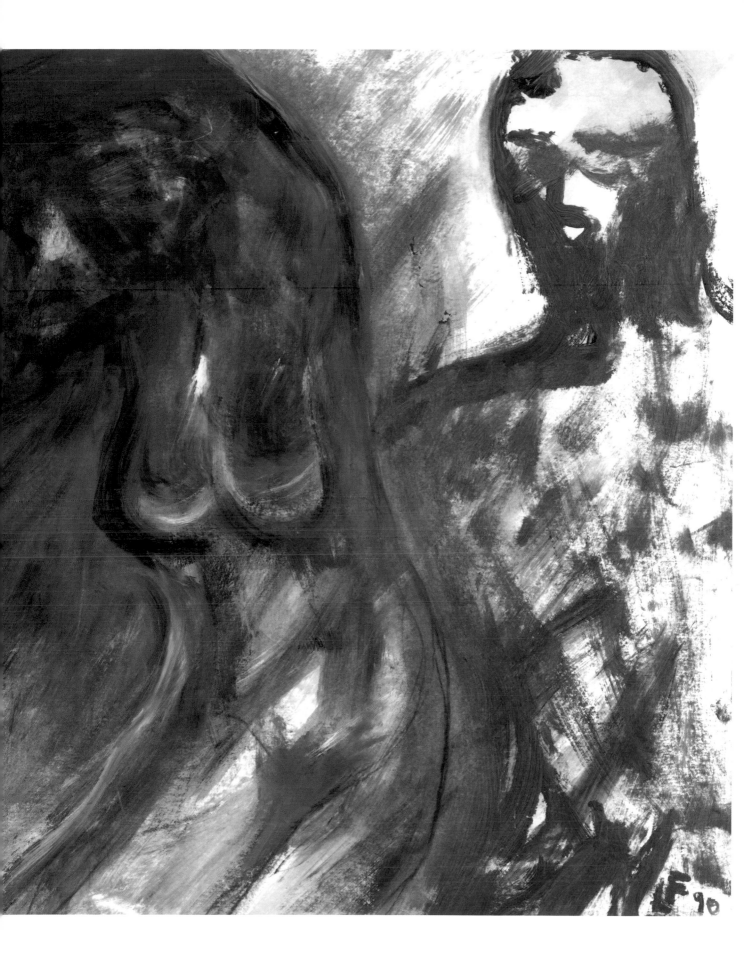

I'M WAITING. 1989. Acrylic, 18½" X 22½"

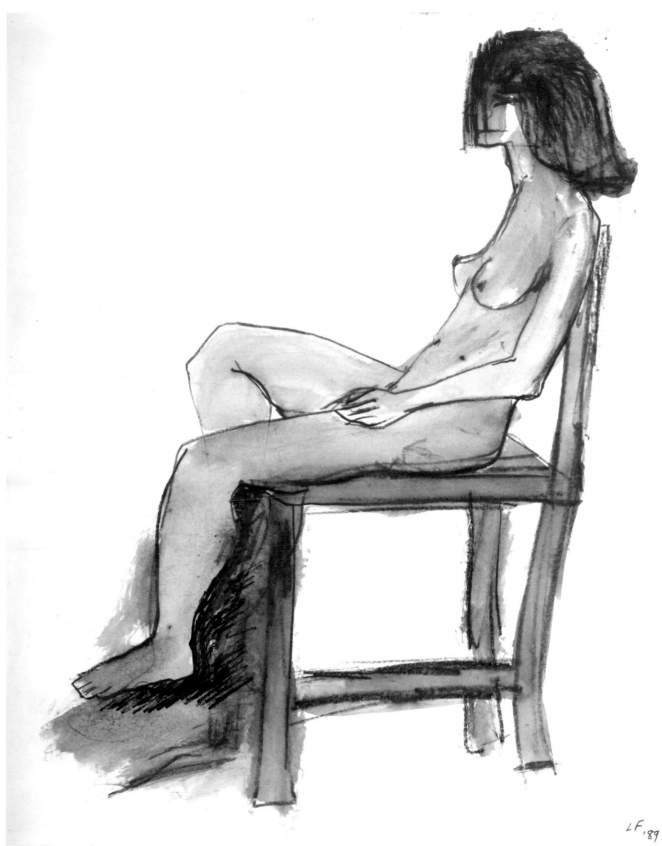

LF '89

A STRANGE COUPLING. 1991. Charcoal, 19" X 24¾"

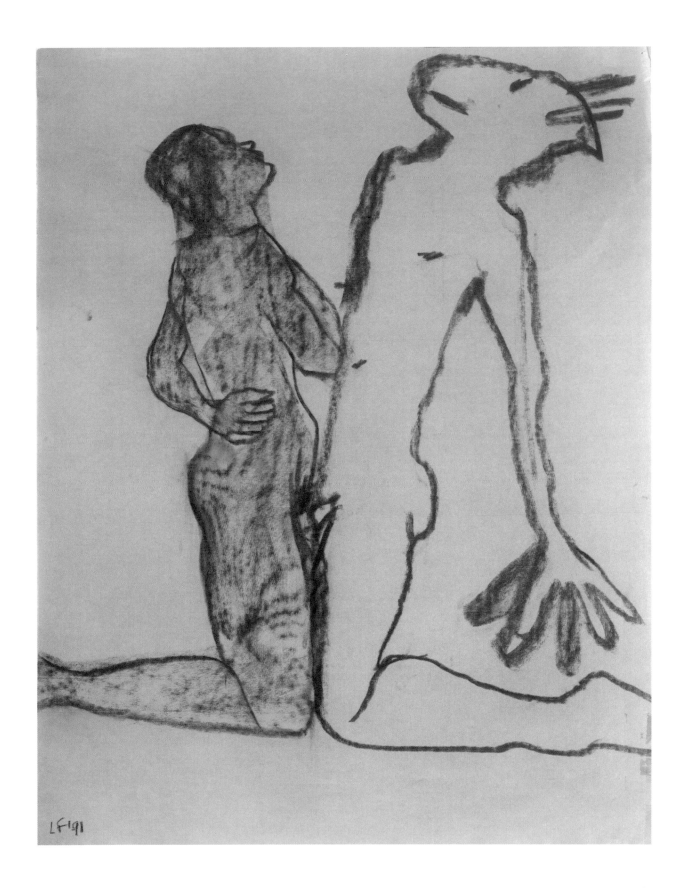

An Unknown Dance with Friends and Enemies. 1991. Acrylic and Charcoal, 18½" X 24¾"

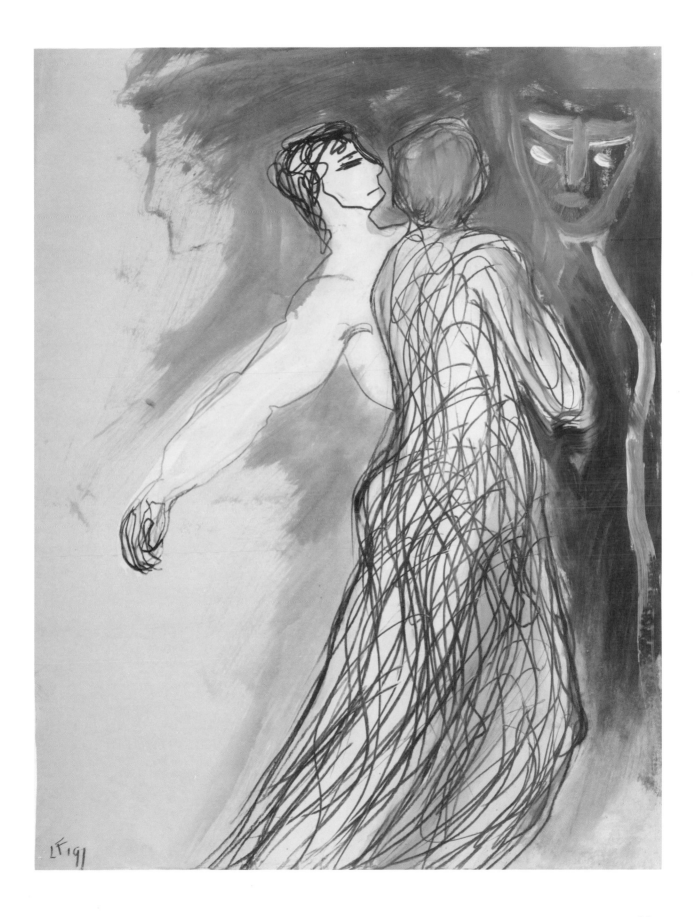

Sᴇx ɪs ᴛʜᴇ Nᴜʀsᴇ ᴏf ᴛʜᴇ Wᴏʀᴋɪɴɢ Cʟᴀss. 1982. Oil and Charcoal, 23¾" X 30½"

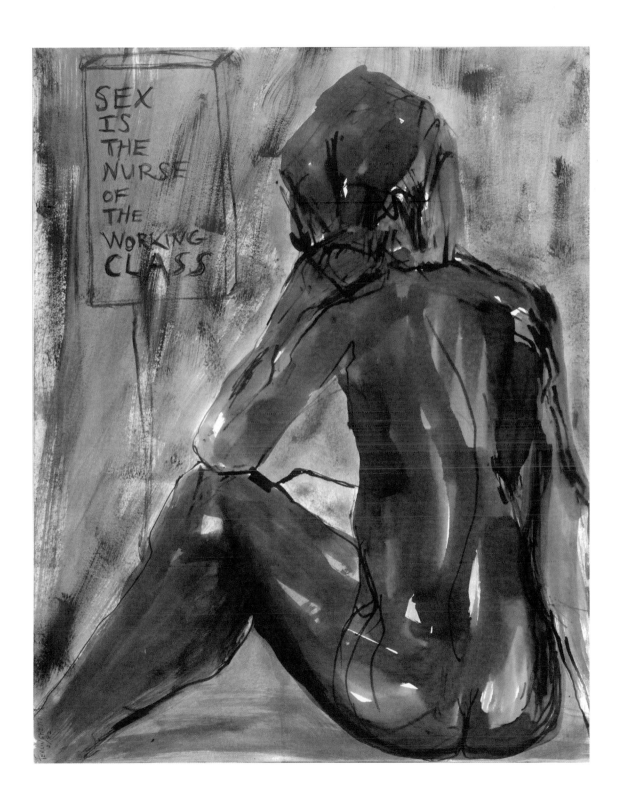

SEX
IS
THE
NURSE
OF
THE
WORKING
CLASS

A Fishy Person. 1985. Acrylic and Charcoal, 23" X 30"

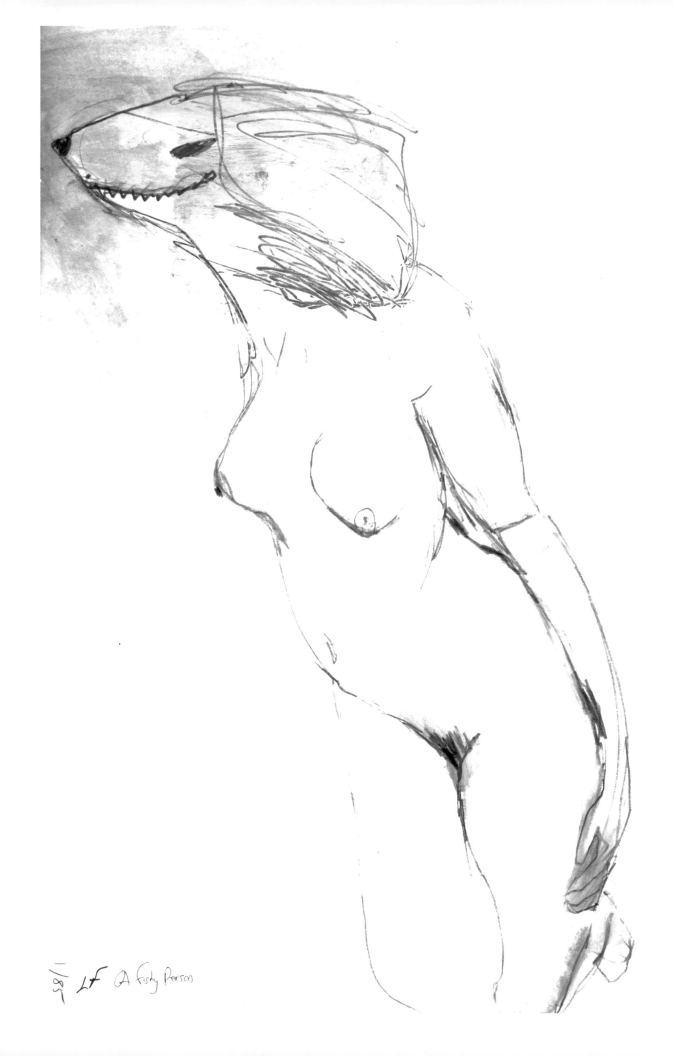

59/168 LF A Fishy Person

ONE NOT VERY HAPPY... 1985. Acrylic, 23" X 27"

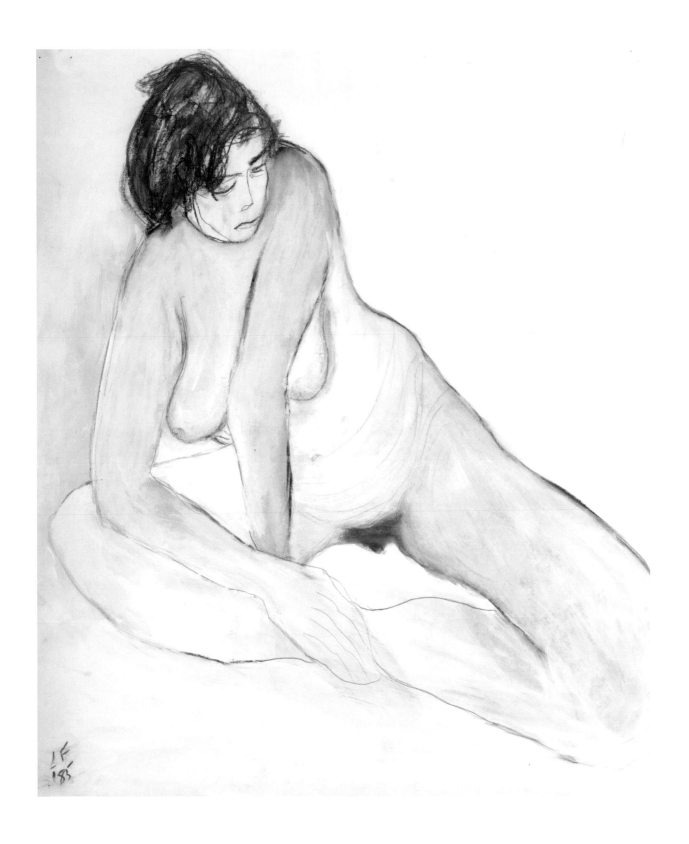

A Happy Woman. 1984. Charcoal, 16" X 24"

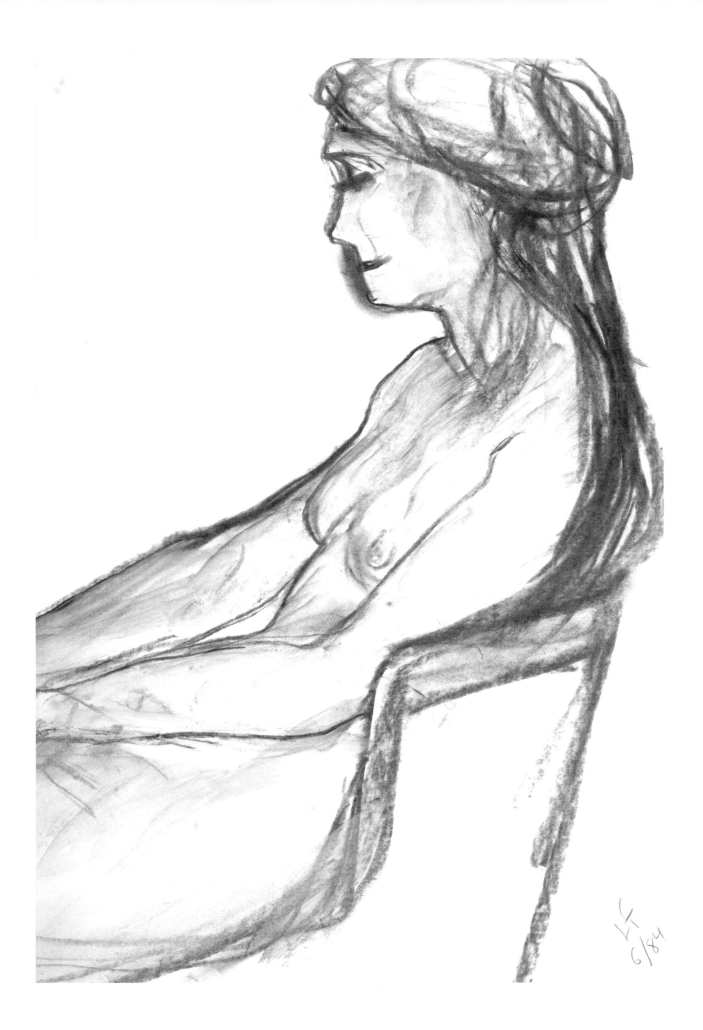

SAMSON ANTAGONISTES. 1984. Acrylic, 23" X 25½"

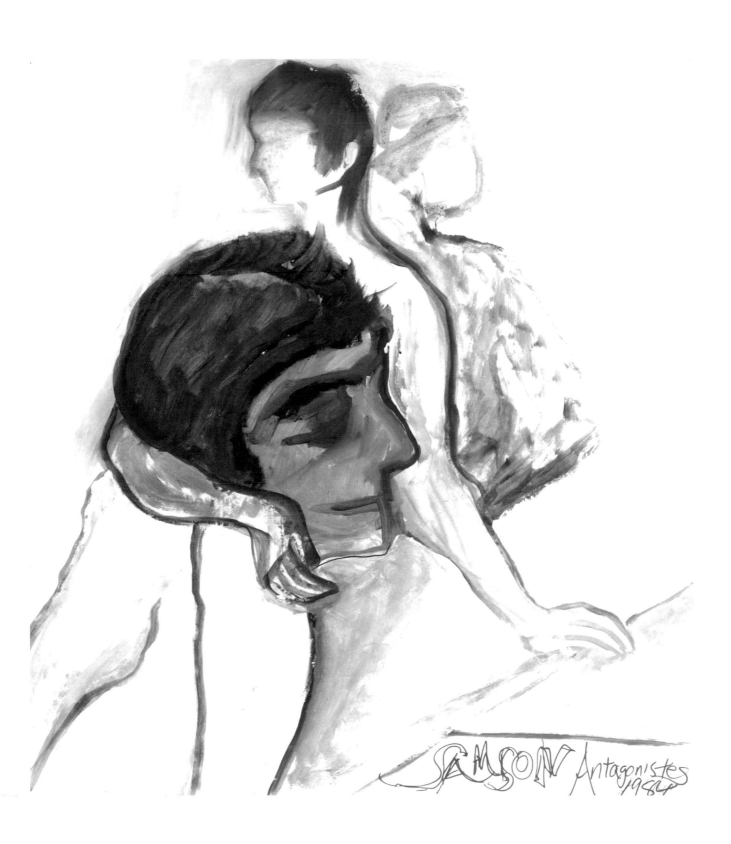

Home Was Never Like This. 1991. Oil and Charcoal, 21½" X 29"

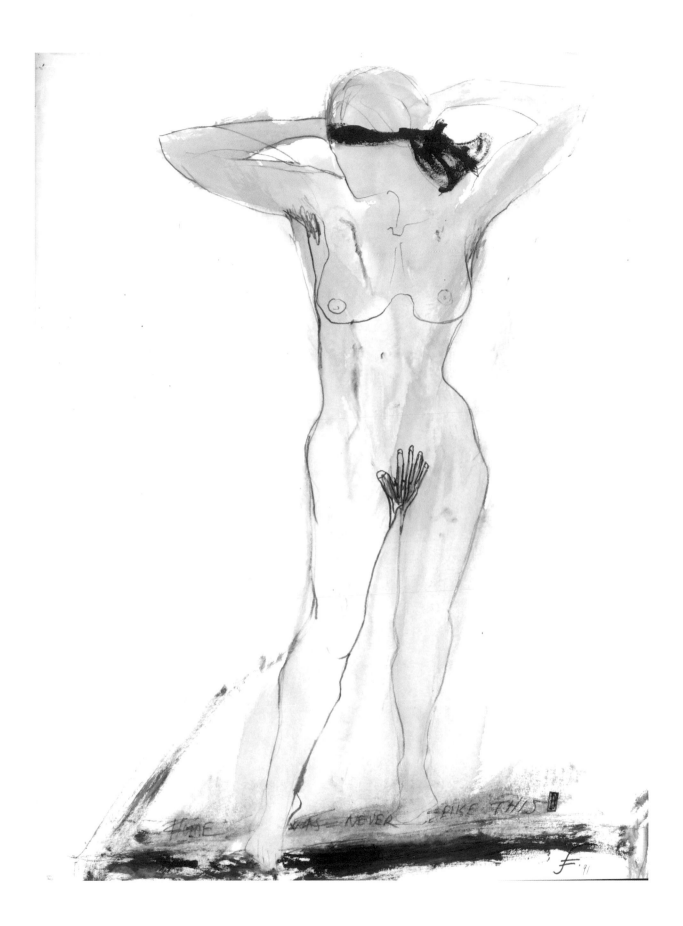

READY TO RUN. 1984. Acrylic, 18" X 23¾"

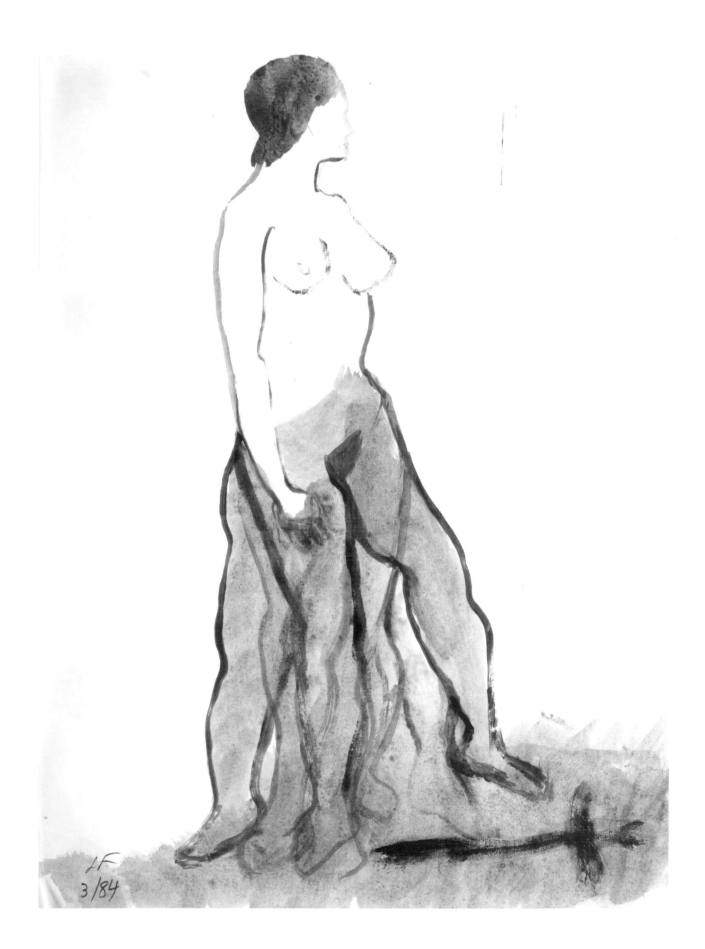

A Red Sea Upon Her. 1998. Acrylic, 23" X 31"

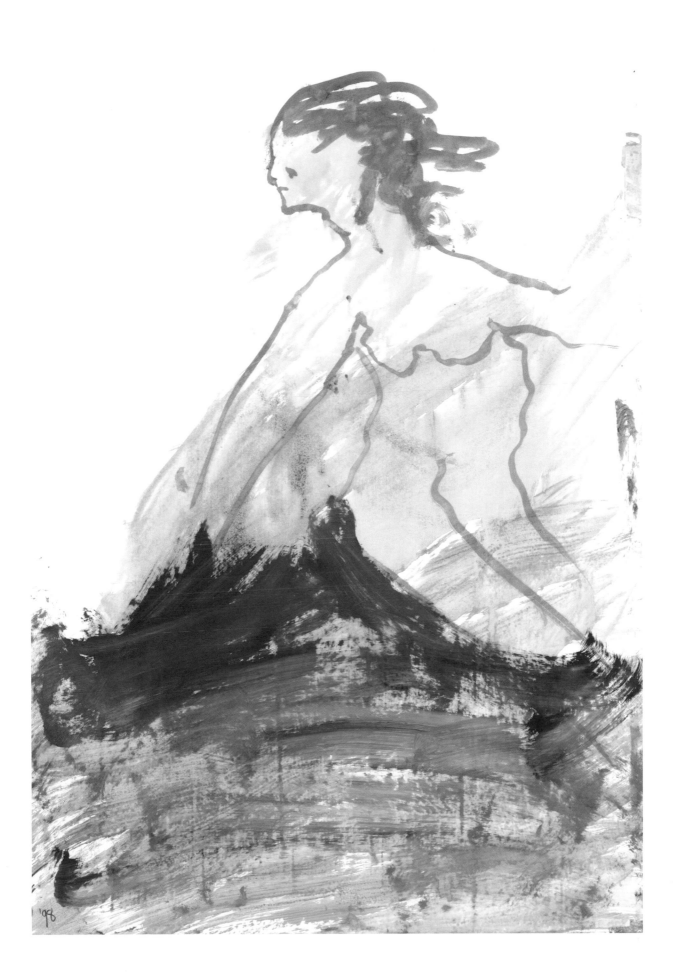

LADY LILAC ATTENDING... 1983. Acrylic and Pen, 18" X 24"

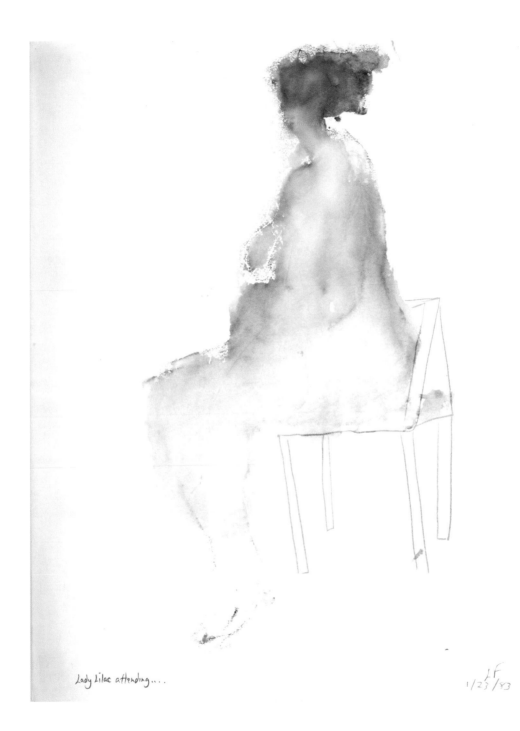

Lady Lilac attending....

LF
1/23/83

Stop. 1991. Acrylic and Ink, 19¾" X 30"

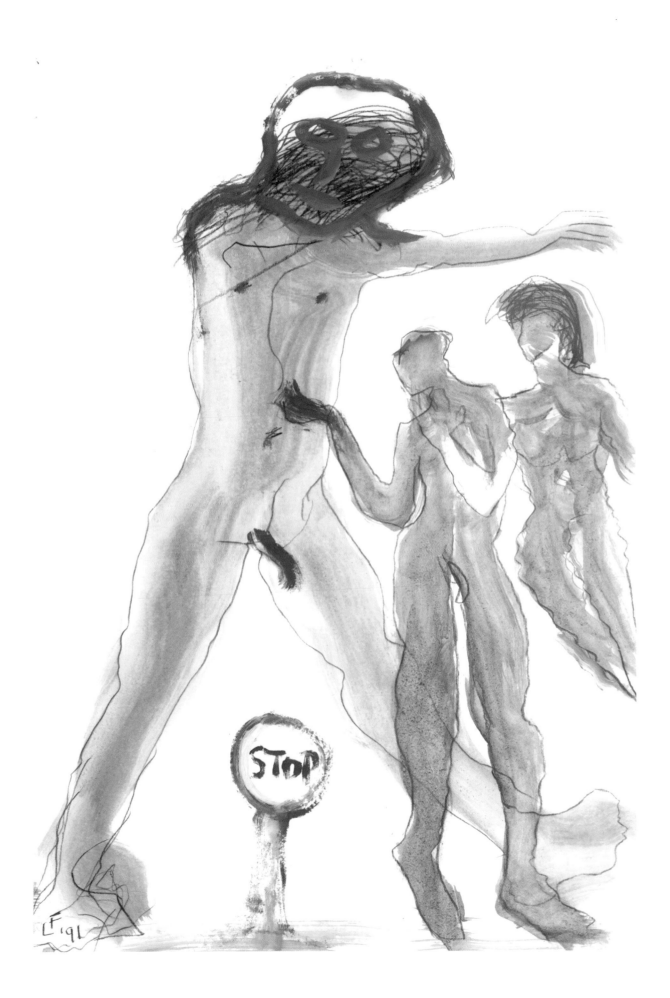

Hasn't Lived Yet. 1984. Acrylic, 22½" X 29½"

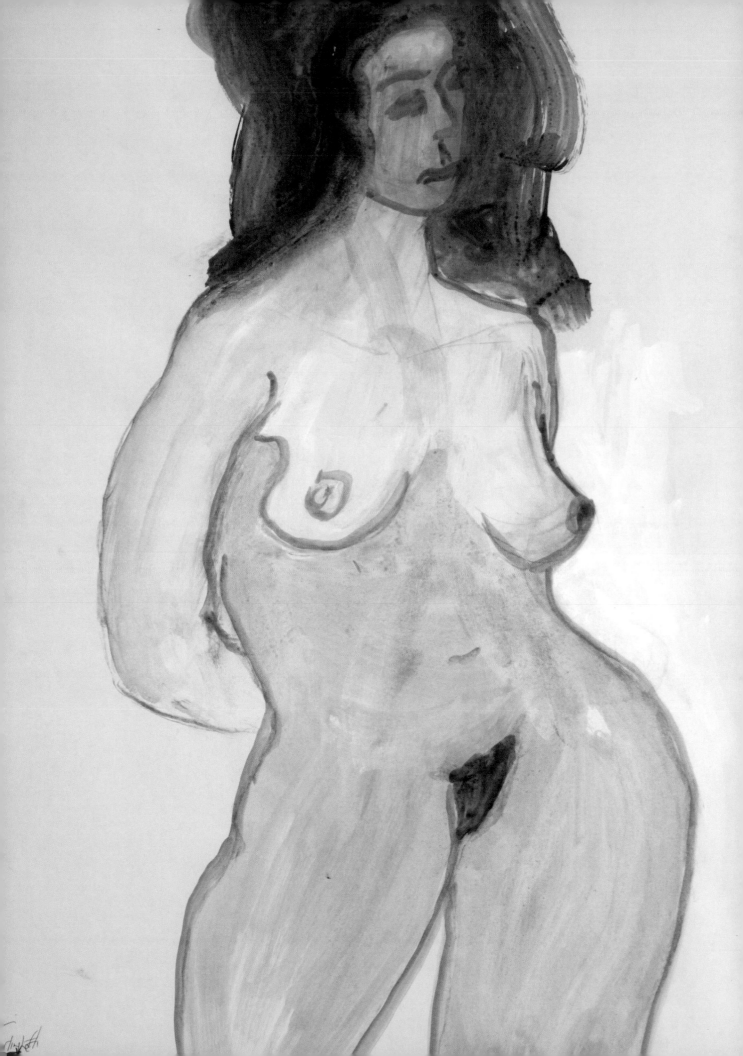

HERMAPHRODITIS. 1984. Acrylic, 23" X 30"

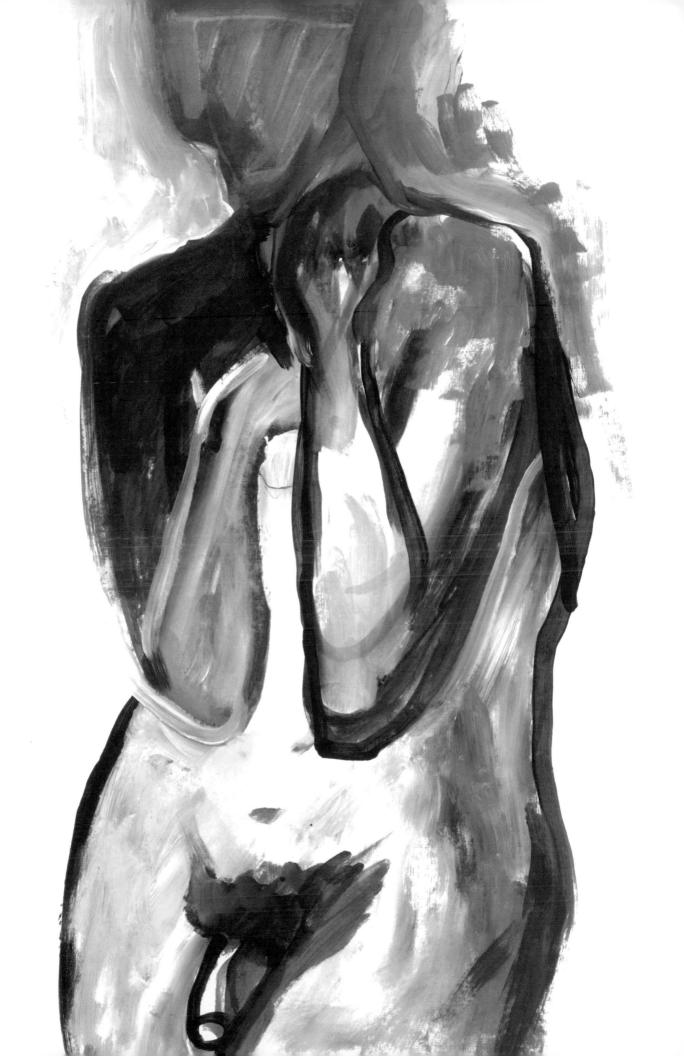

A BLUE STUDY. 1990. Acrylic and Charcoal, 27½" X 22½"

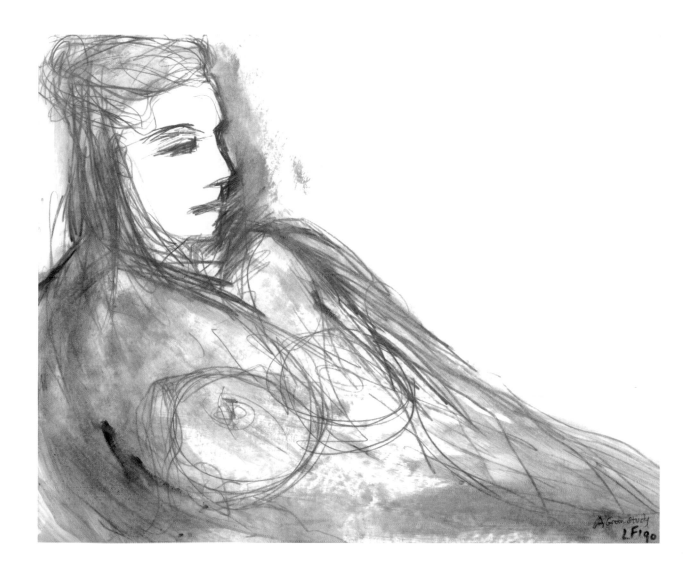

THINKING OF YOU TONIGHT. 1991. Acrylic and Charcoal, 23" X 29¾"

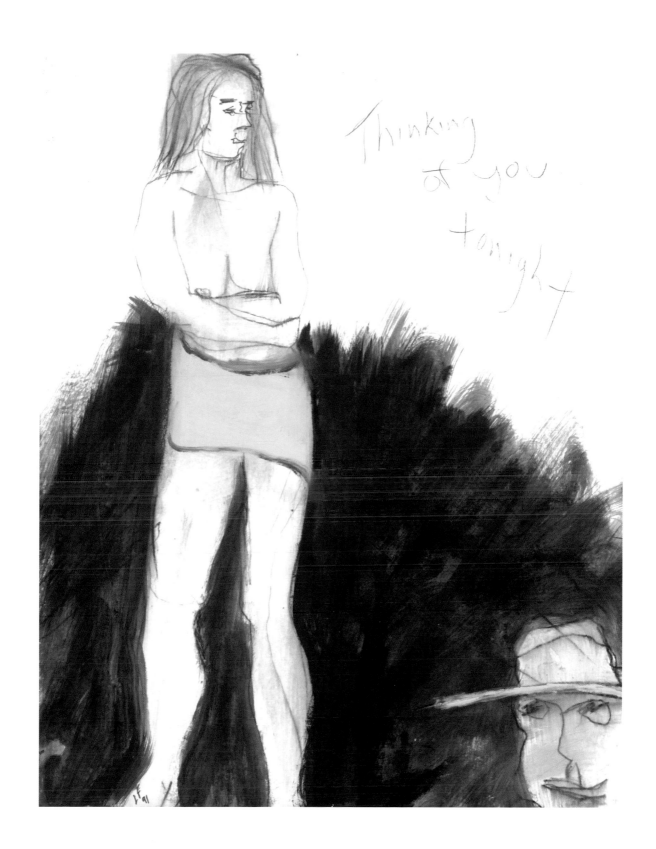

A Devastation. 1990. Charcoal and Pencil, 24" X 18"

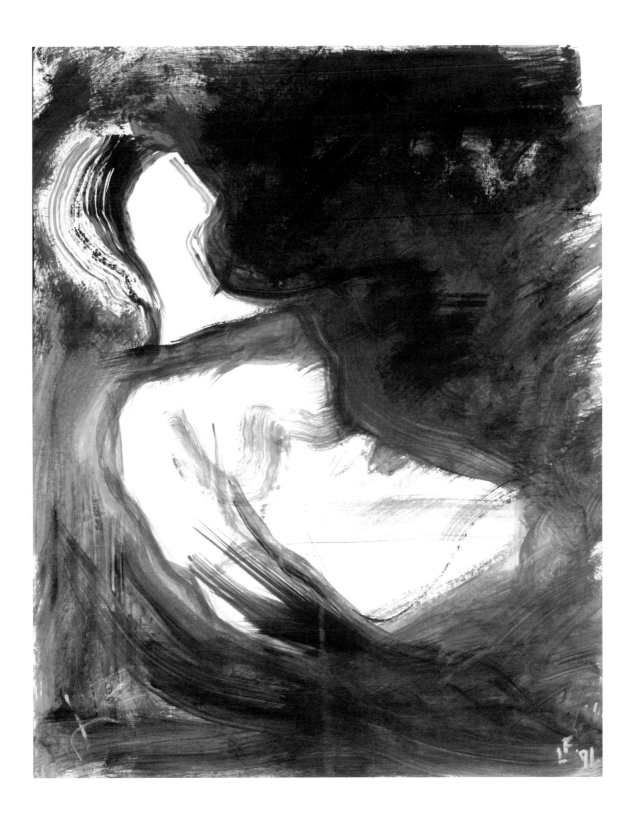

It's Too Late For Thinking. 1981. Acrylic, 18" X 24"

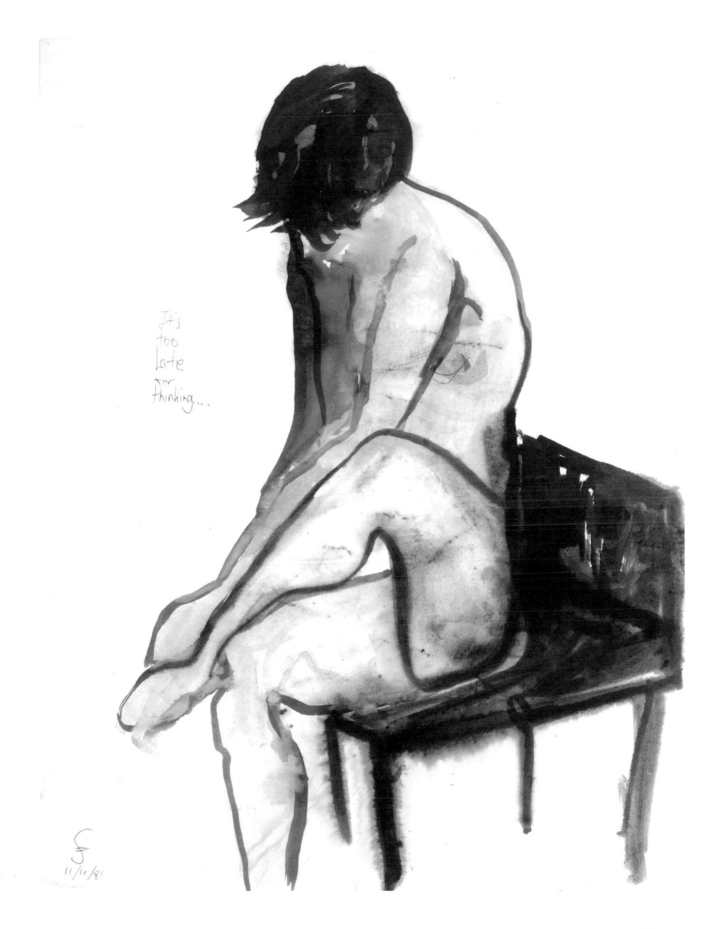

It's
too
Late
For
Thinking....

F
11/10/81

NARCISSE, NARCISSE. 1991. Acrylic, 23" X 28"

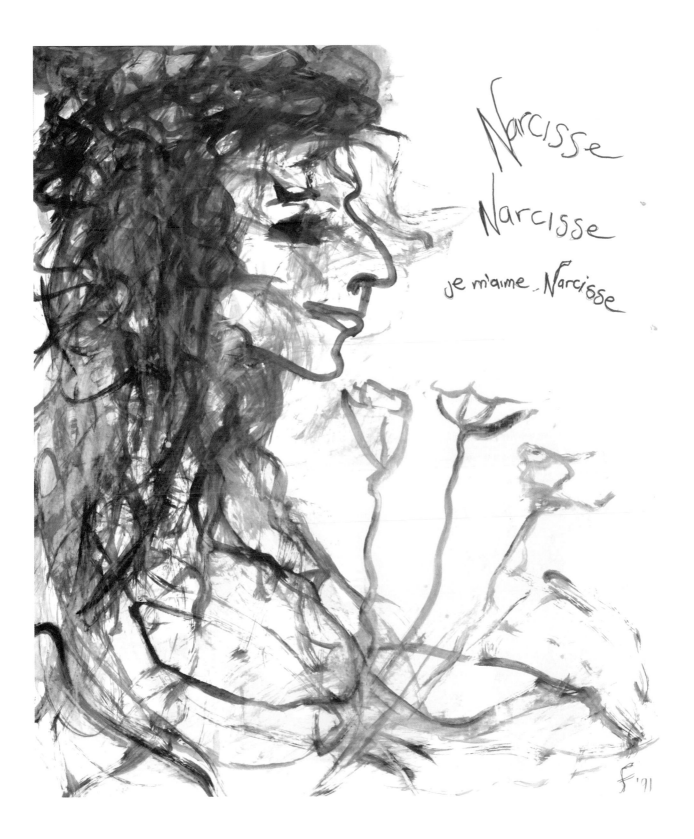

Narcisse
Narcisse
je m'aime - Narcisse

F'71

QUITE OUT OF IT. 1990. Acrylic, 23" X 29½"

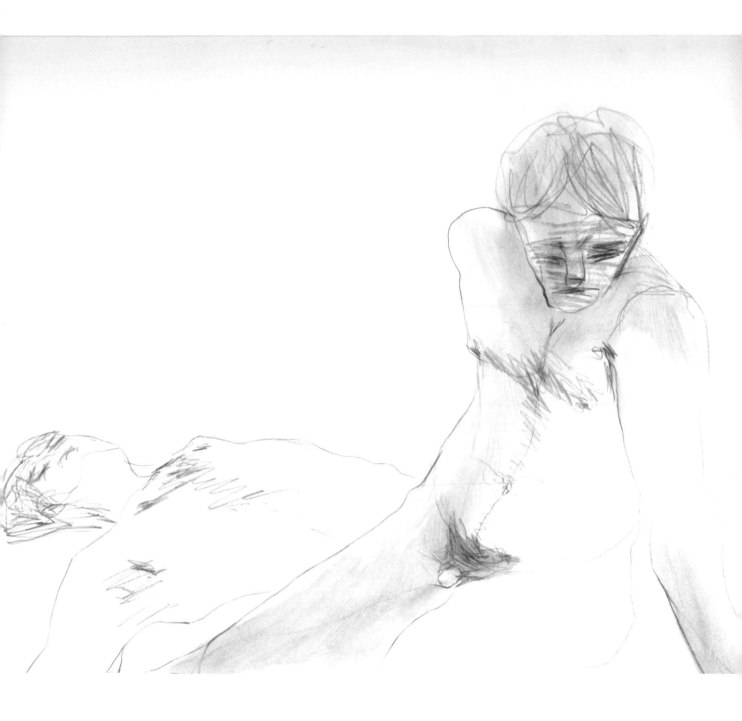

WHAT IS SO STRANGE AS A MAN IN BLOOM. 1984. Acrylic and Charcoal, 14½" X 25"

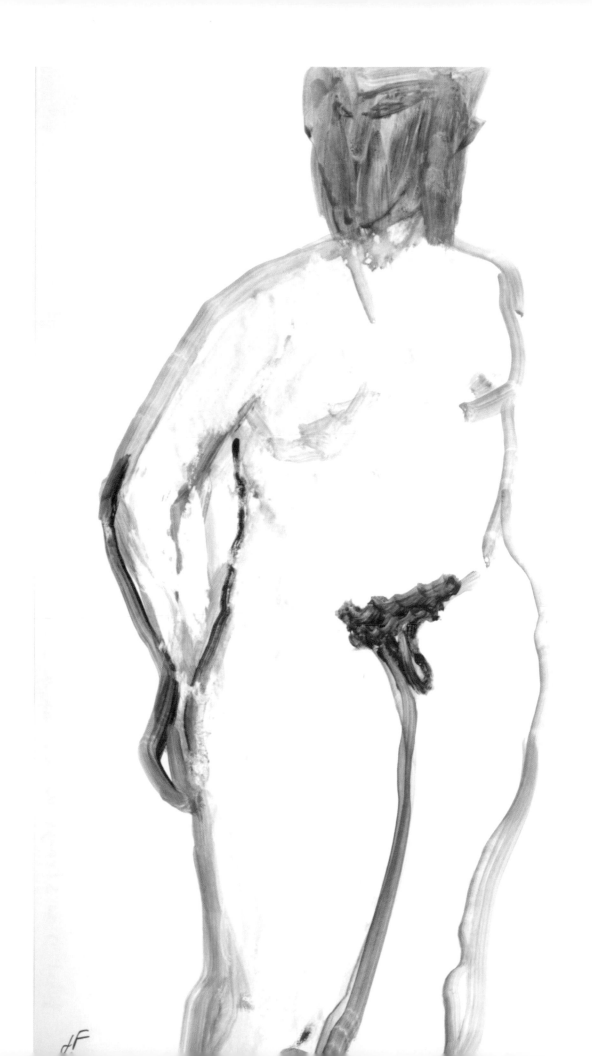

THROUGH THE SURF. 1984. Acrylic, 19" X 25"

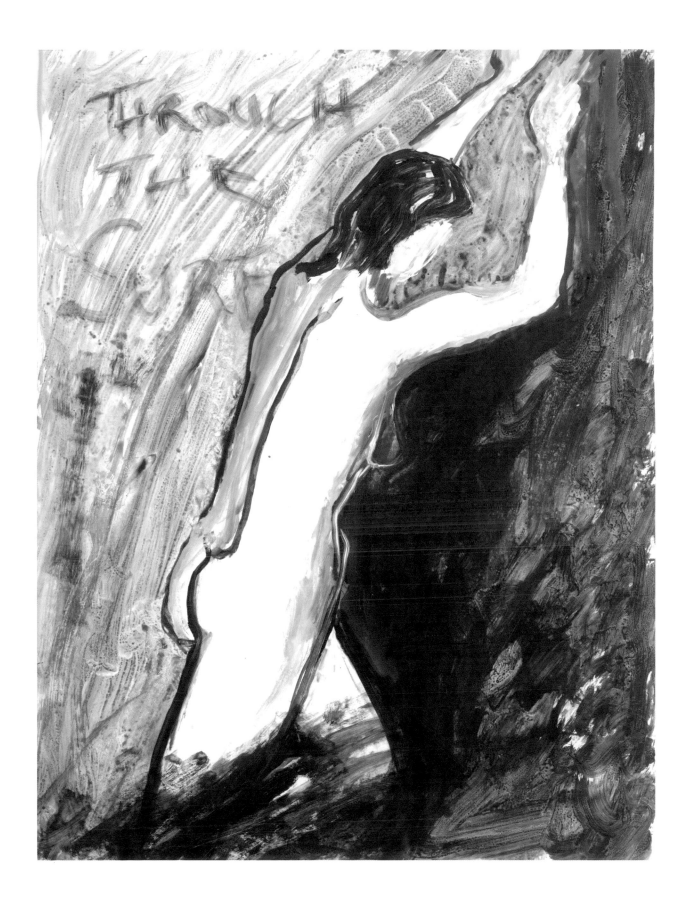

BLACK AND WHITE QUANDARY. 1984. Acrylic, 17¾" X 24¾"

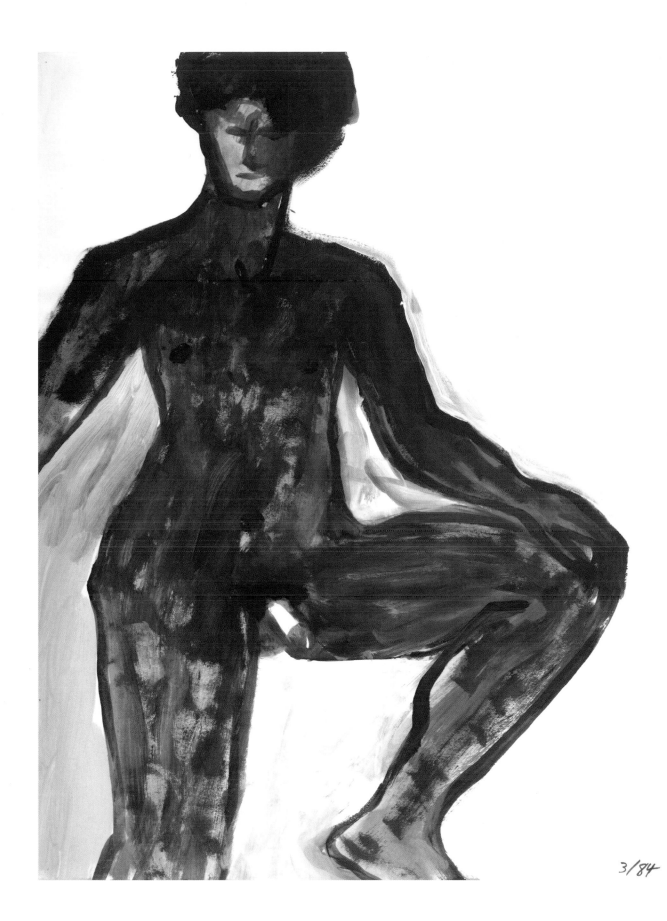

3/84

Don't Flux With Me. 1982. Ink and Charcoal, 13¾" X 17"

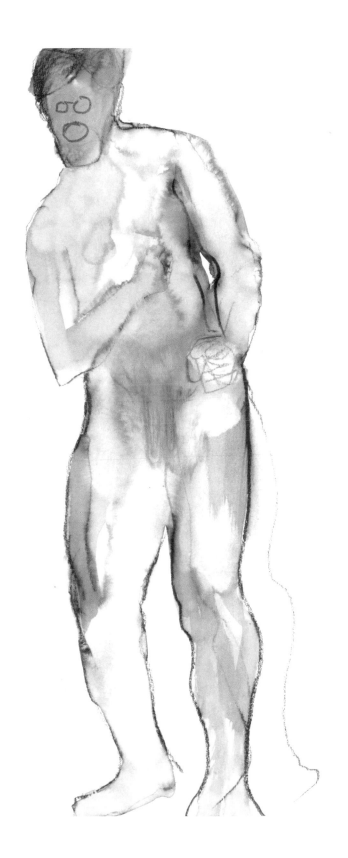

LF '82

THE HULK. 1981. Acrylic, 18" X 23¾"

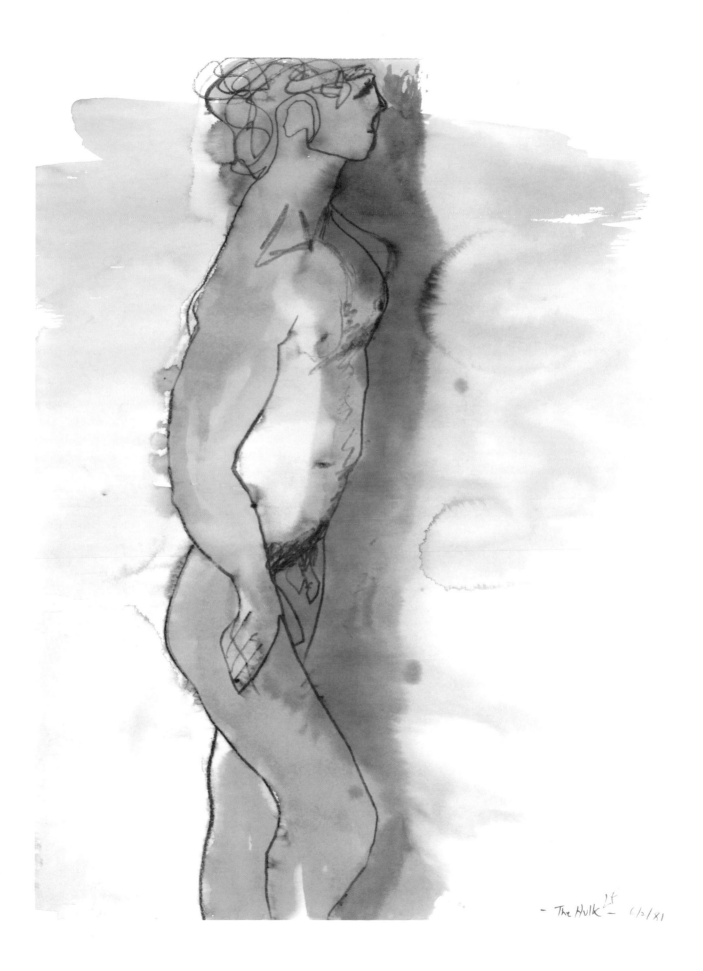

– The Hulk – 6/2/81

THE TIGER WITHIN. 1994. Ink and Pencil, 13½" X 17"

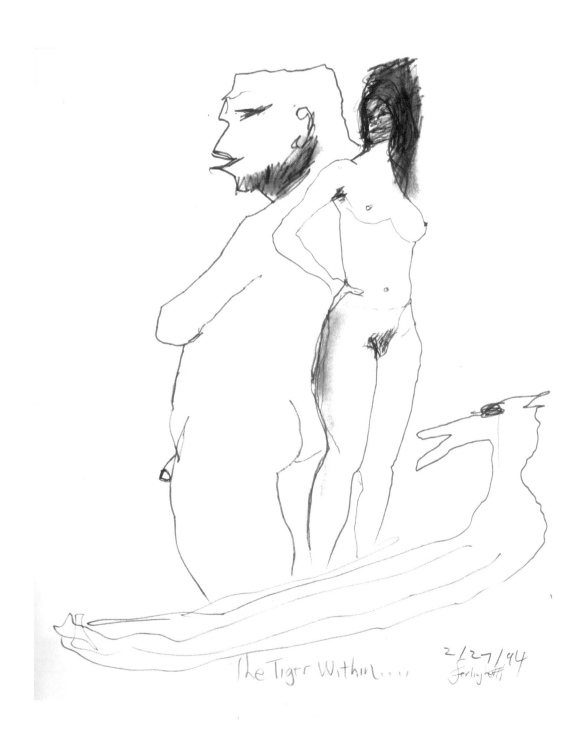

The Tiger Within.... 2/27/94
 Ferlinghetti

WOUNDED MAN. 1993. Oil, 21¾" X 32½"

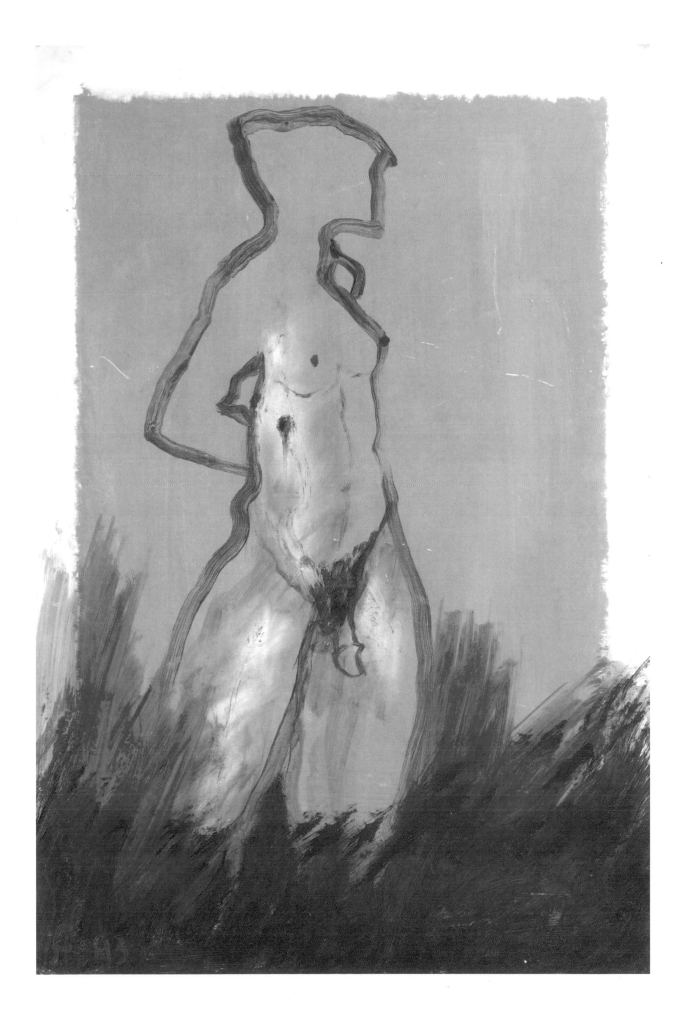

THE SUITORS. 1997. Acrylic, 26¾" X 20½"

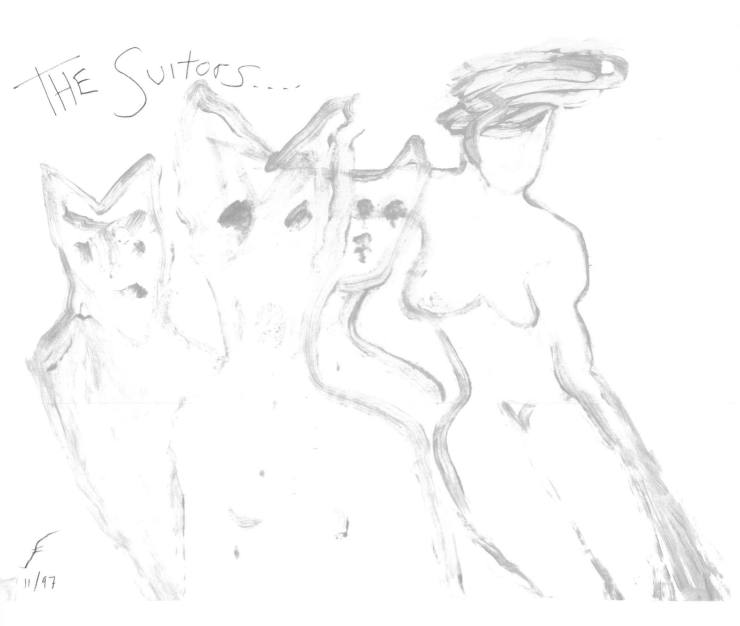

THE Suitors....

F
11/97

HAVE BODY, WILL TRAVEL. 1982. Ink, 15" X 17½"

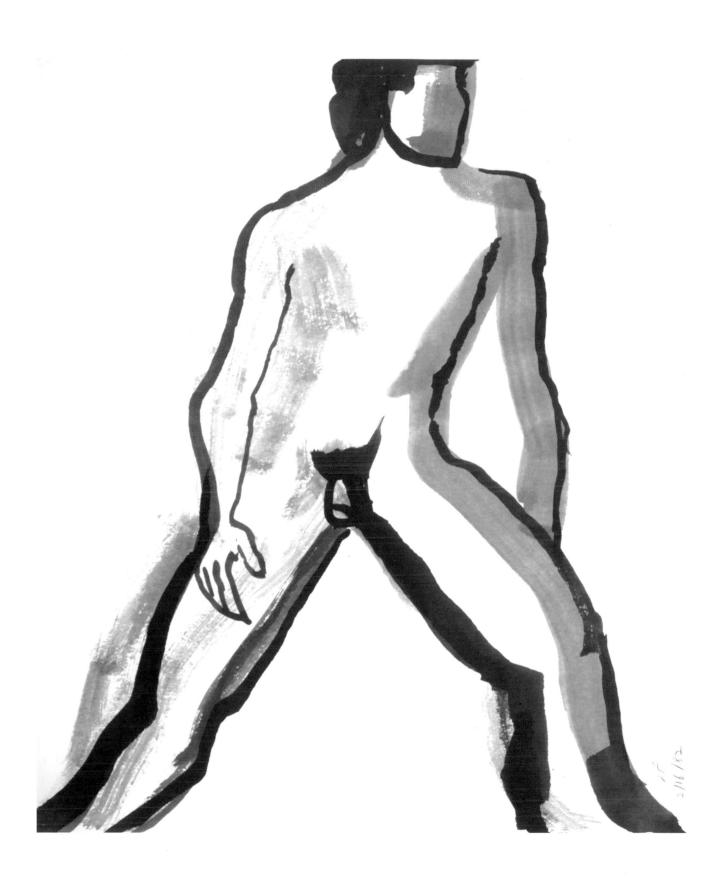

HAD A HARD LIFE. 1982. Acrylic, 14" X 16½"

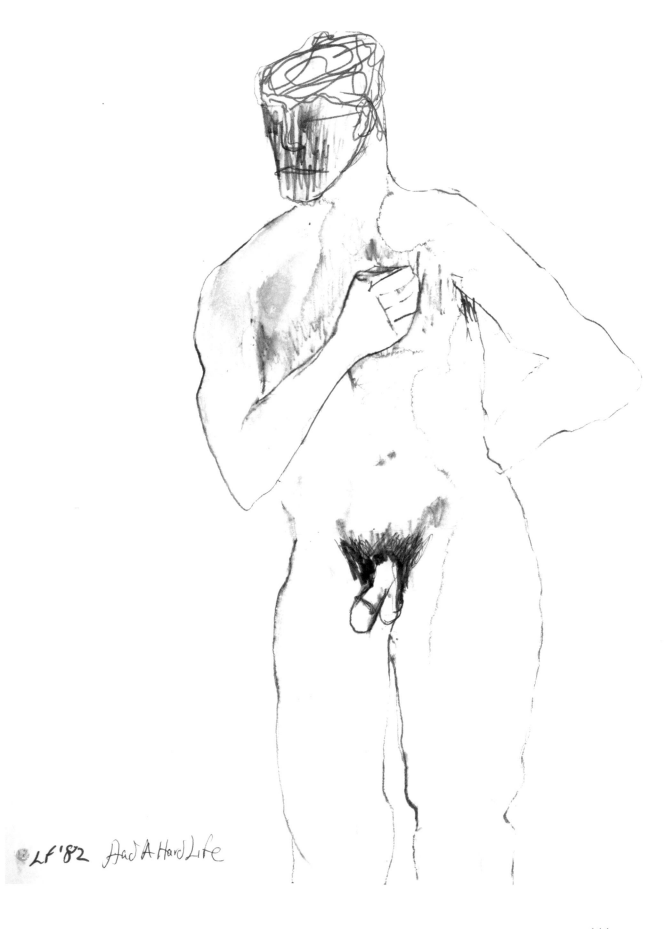

LF '82 Had A Hard Life

A Hard Man. 1991. Oil, 15" X 22½"

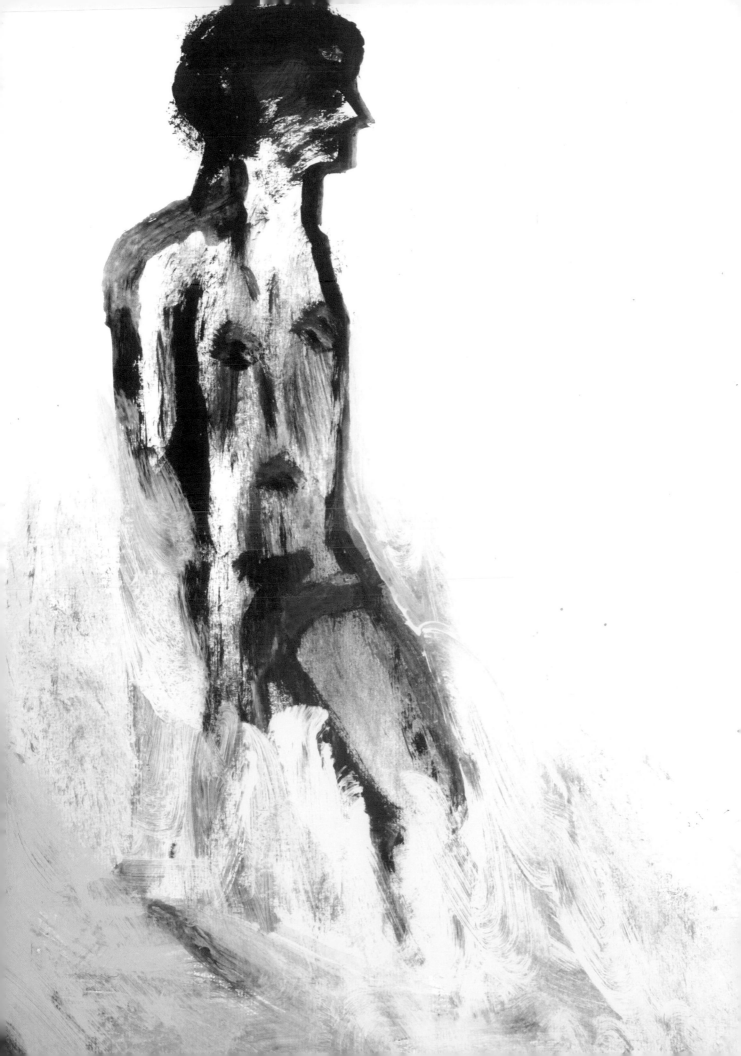

THE END PRODUCT. 1991. Oil and Acrylic, 20" X 30"

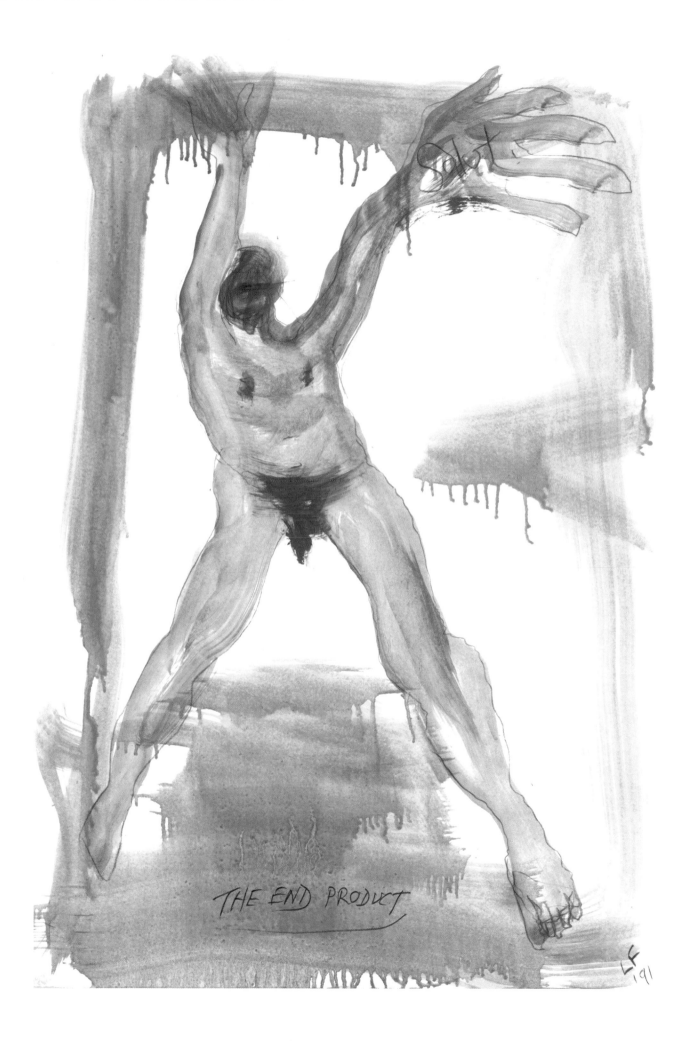

THE END PRODUCT

I Left My Memory in Hock. 1993. Acrylic over print, 15" X 22"

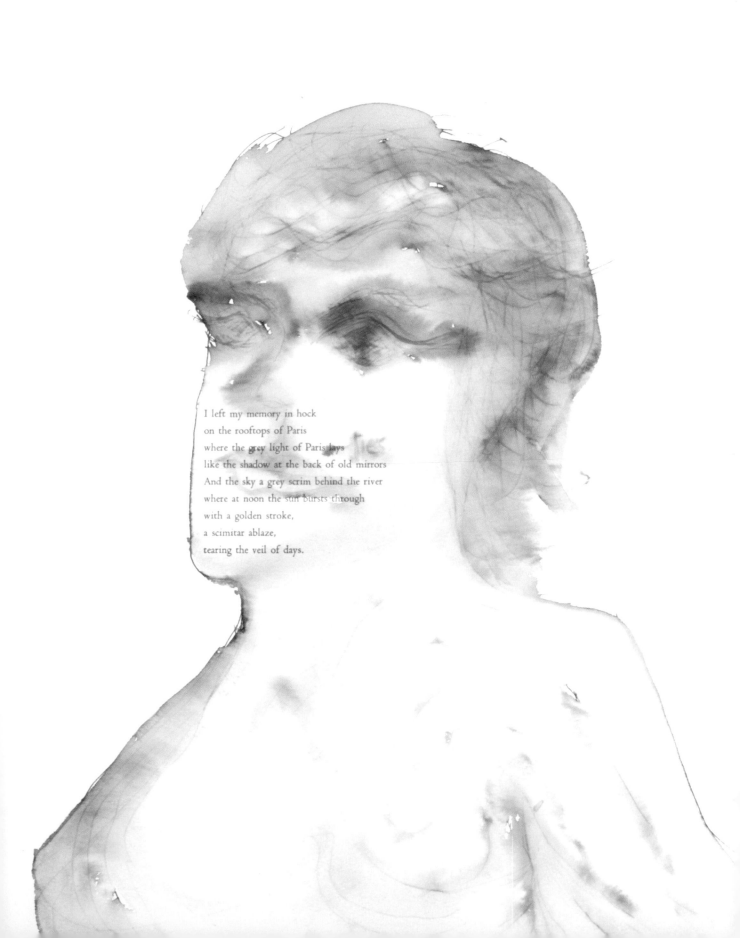

I left my memory in hock
on the rooftops of Paris
where the grey light of Paris lays
like the shadow at the back of old mirrors
And the sky a grey scrim behind the river
where at noon the sun bursts through
with a golden stroke,
a scimitar ablaze,
tearing the veil of days.

On the Rooftops of Paris. 1993. Charcoal over print, 15" X 22"

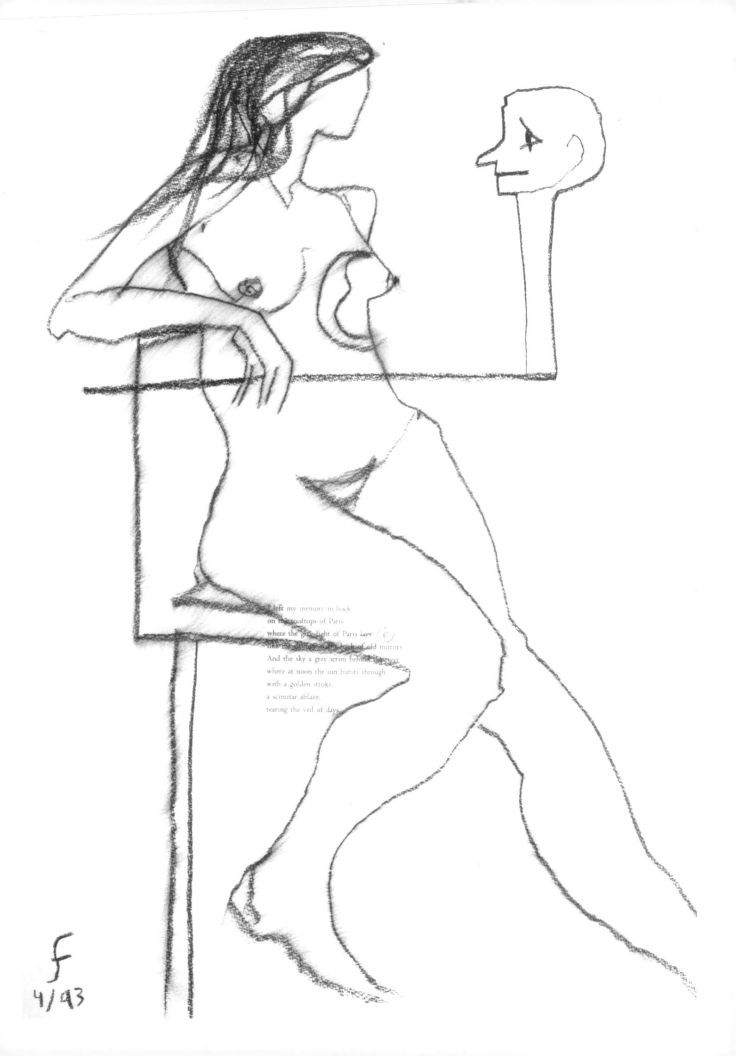

I left my memory in hock
on the rooftops of Paris
where the grey light of Paris lays
like the tarnished edge of old mirrors
And the sky a grey scrim behind the river
where at noon the sun bursts through
with a golden stroke,
a scimitar ablaze,
tearing the veil of days.

f
4/93

BACK OF OLD MIRRORS. 1993. Acrylic over print, 15" X 22"

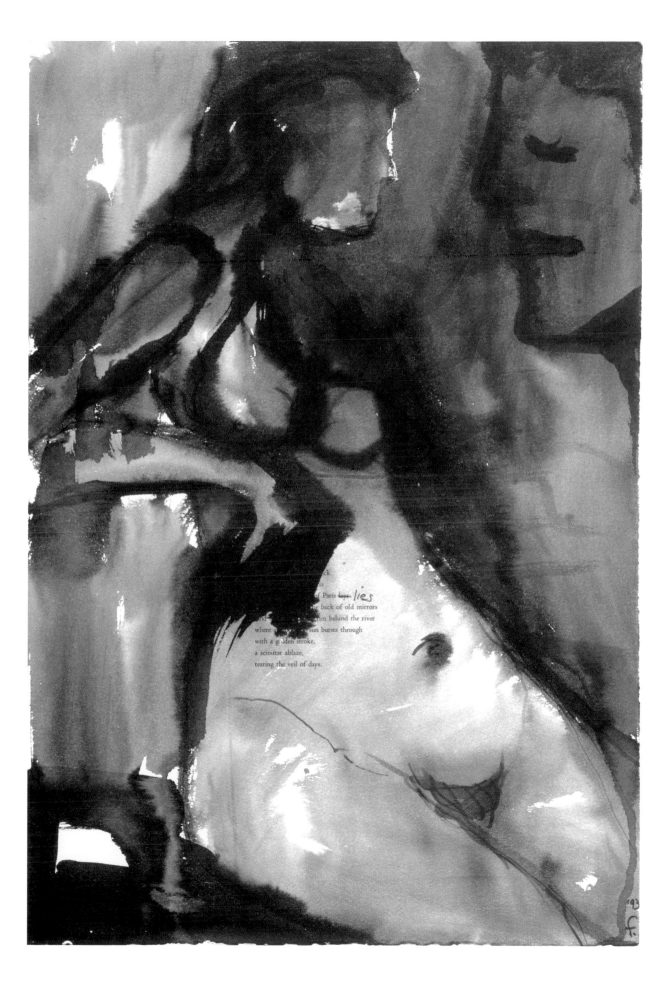

...ck

...is

...of Paris ~~lays~~ *lies*

...e back of old mirrors

...rim behind the river

where ...e sun bursts through

with a golden stroke,

a scimitar ablaze,

tearing the veil of days.

Hands: an Attack #1. 1991. Monoprint, 16" X 16"

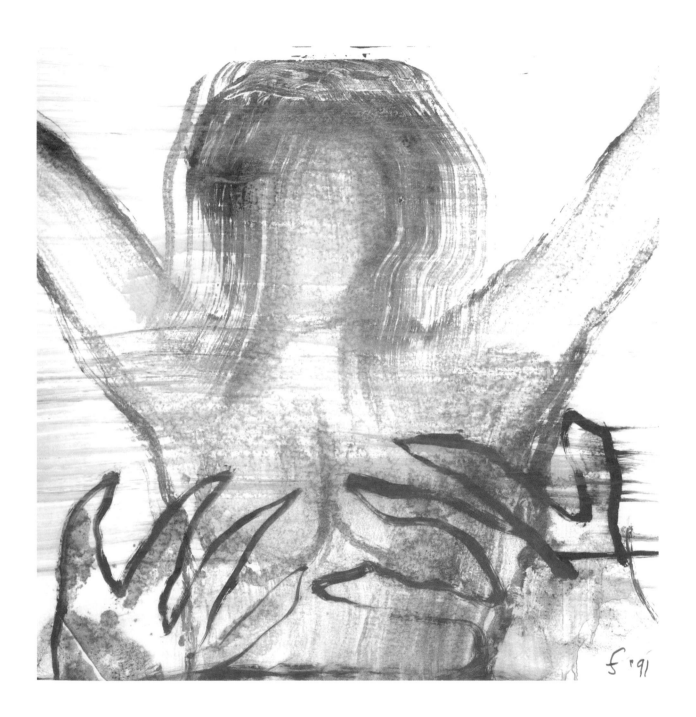

Hands: an Attack #2. 1991. Monoprint, 24" X 32½"

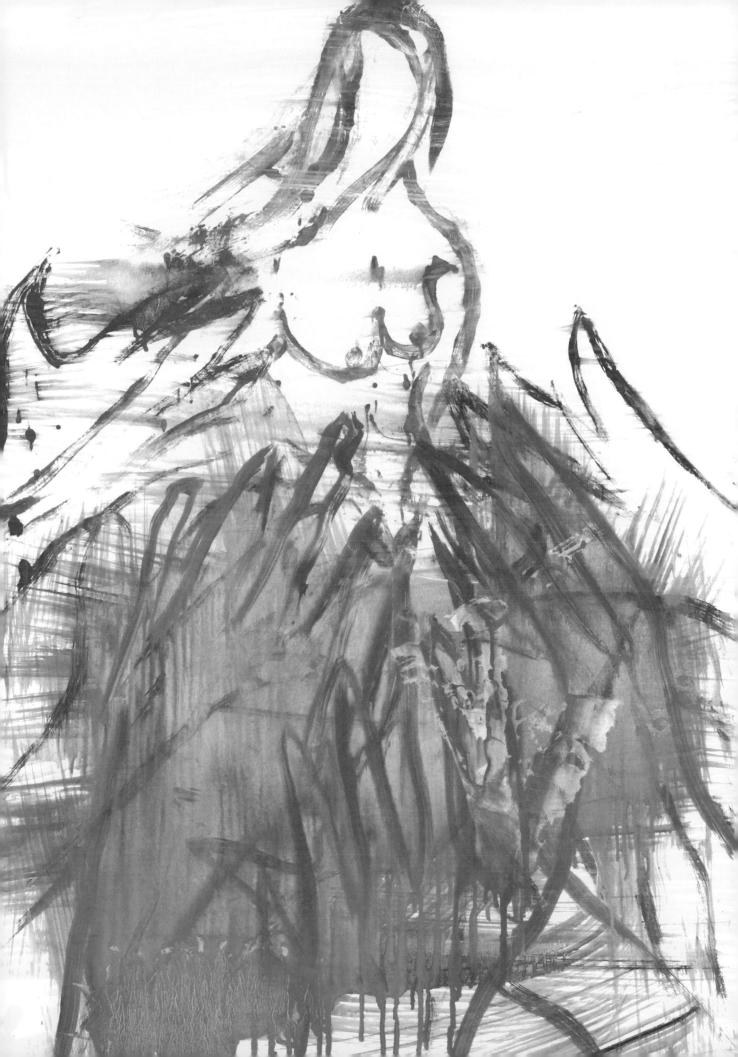

THE PEACE-NIK REJECTED. 1989. Acrylic, 22½" X 22½"

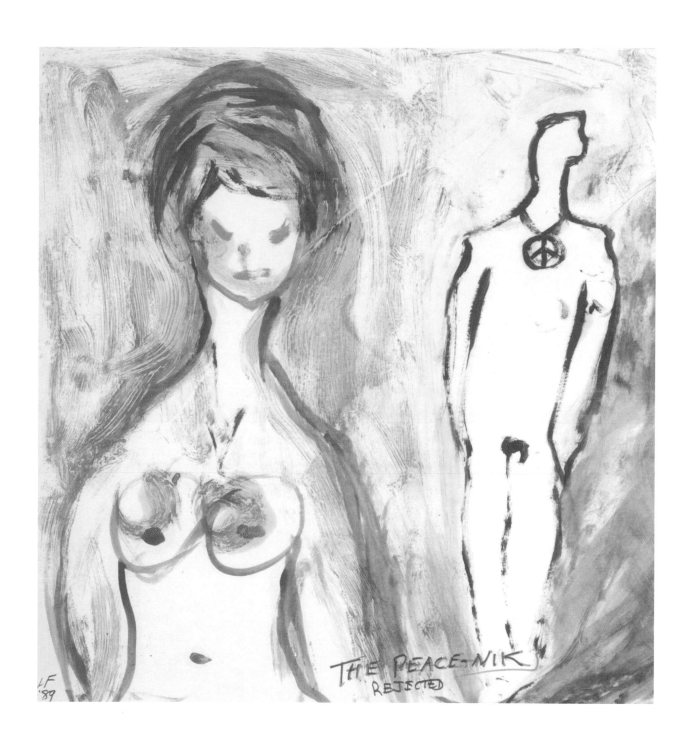

THE PEACE-NIK
REJECTED

LF
'89

WHAT OF THE NIGHT. 1992. Monoprint, 20" X 28"

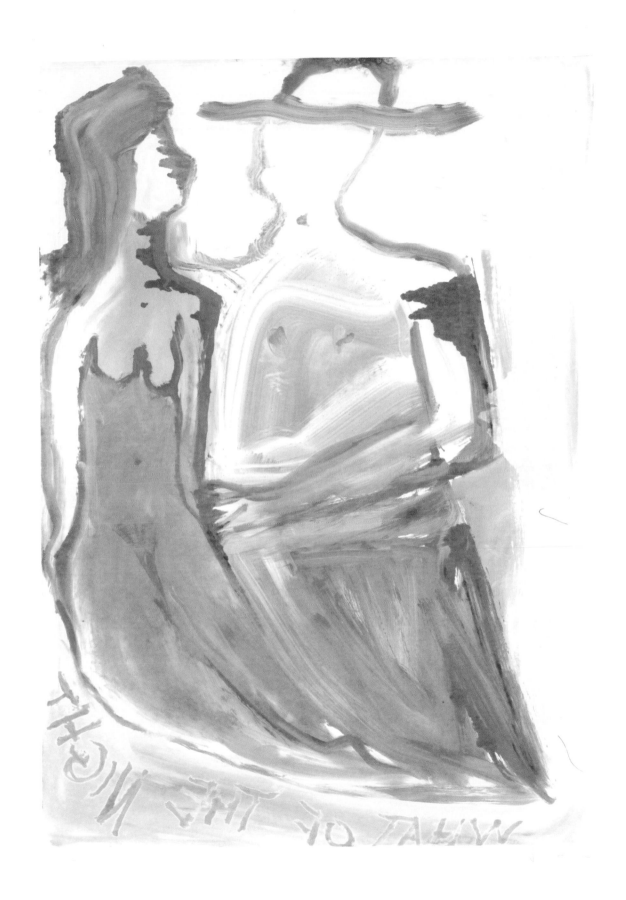

THE HUMAN FORM. 1983. Acrylic and Charcoal, 32" X 21½"

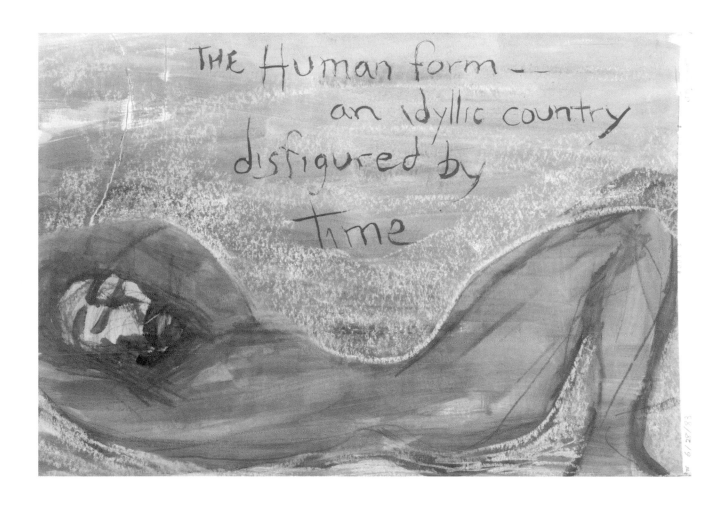

THE Human form --
an idyllic country
disfigured by
Time

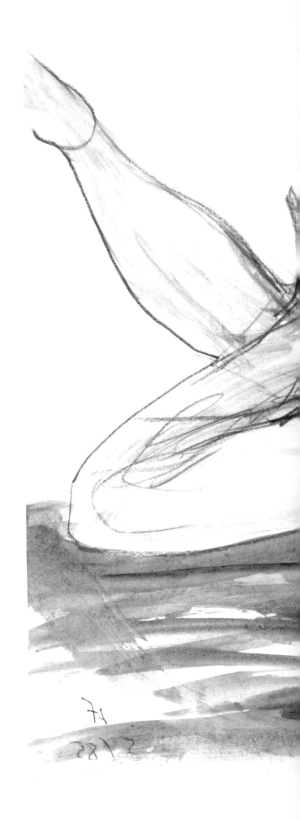

IF THE SUN COULD THINK. 1985. Acrylic and Charcoal, 25" X 19"

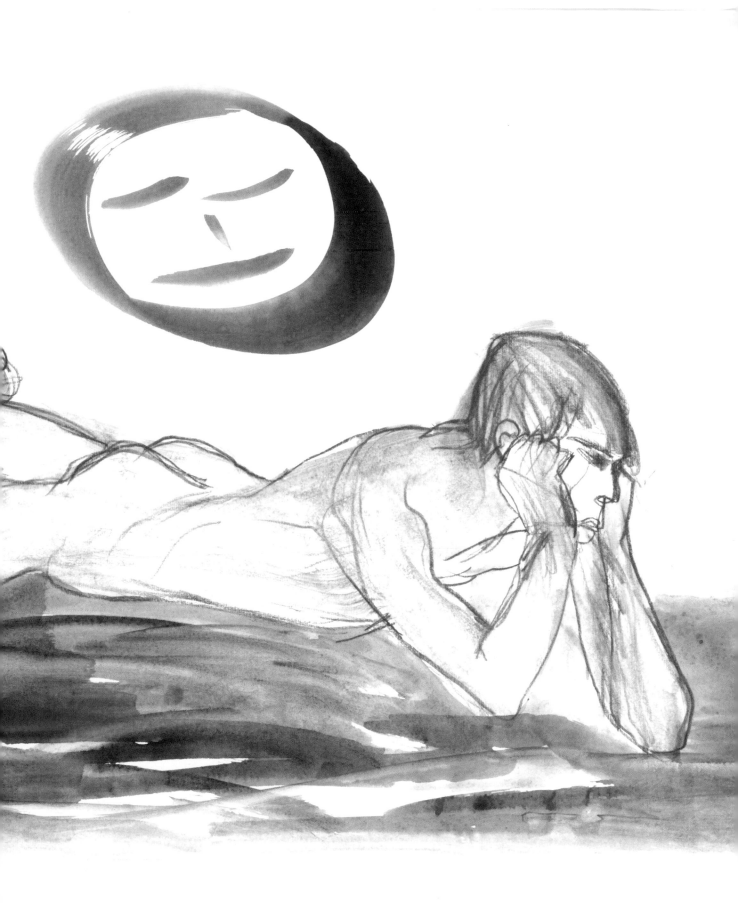

FREUD. 1992. Lithograph, 15" X 19½"

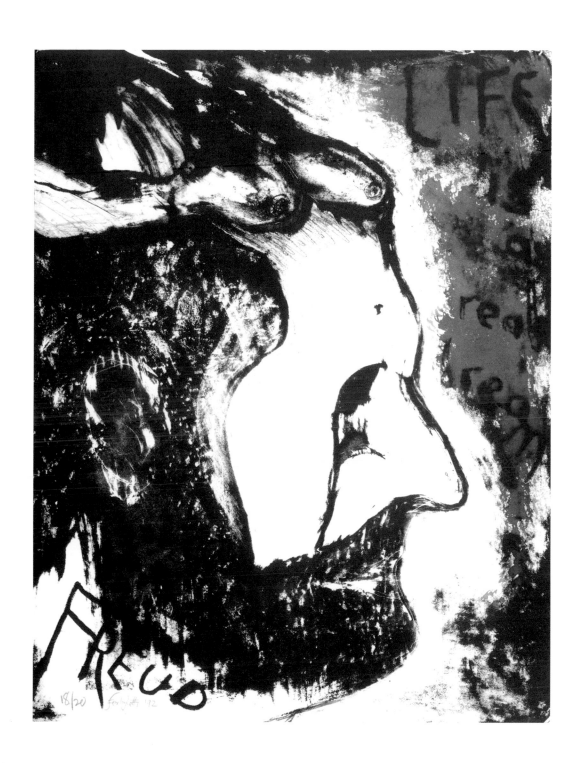

MARILYN. 1984. Acrylic and Charcoal, 26" X 23"

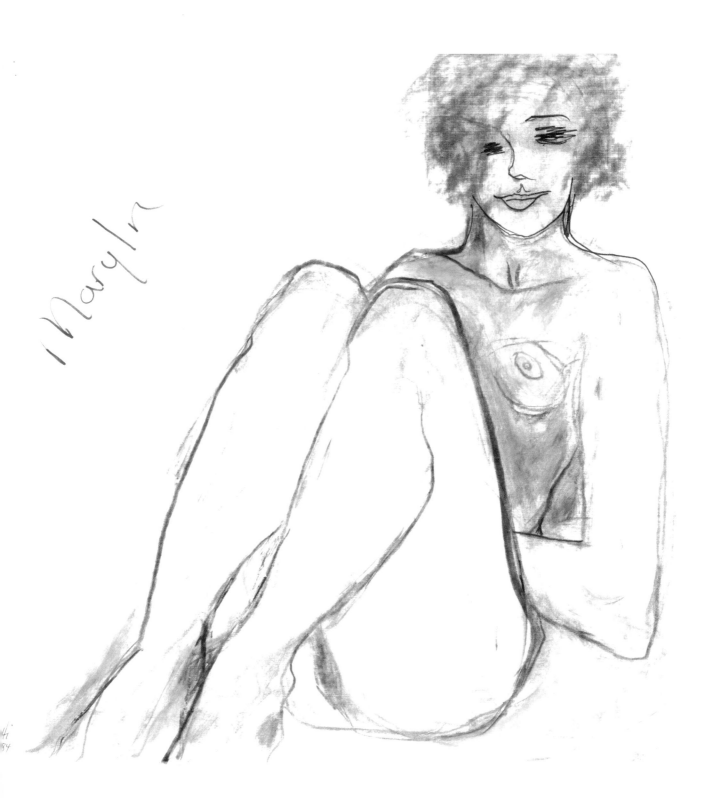

Maryln

Camelot (for Jacqueline). 1987. Acrylic, 21" X 30"

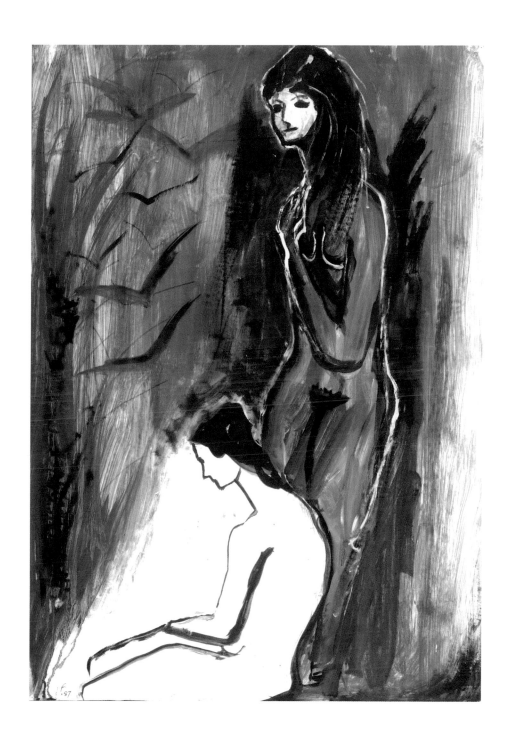

D.H. LAWRENCE. 1997. Charcoal, 23" X 28"

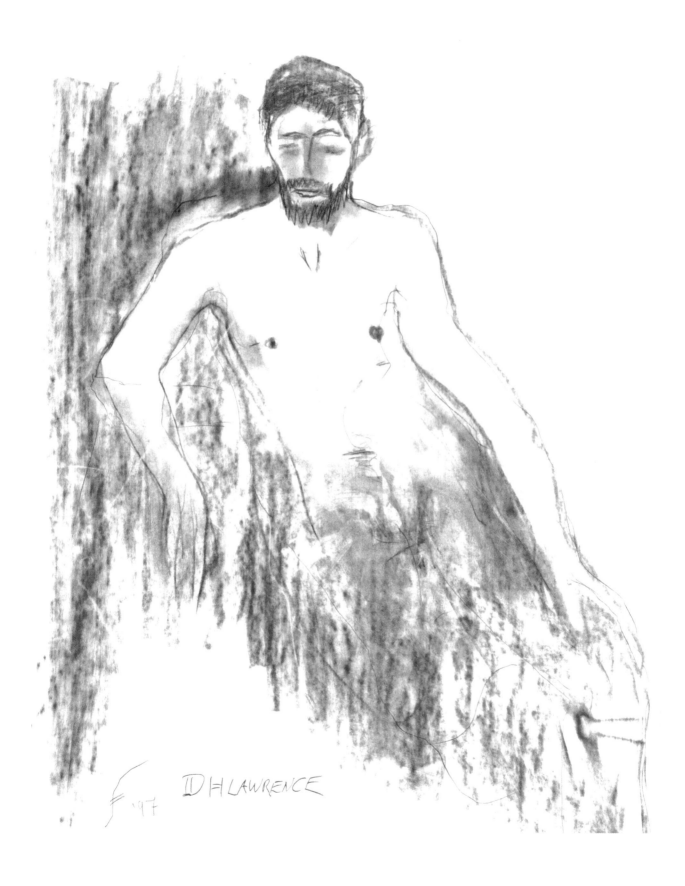

D H LAWRENCE

PRAGUE THROUGH THE CENTURIES. 1997. Oil, 21½" X 30"

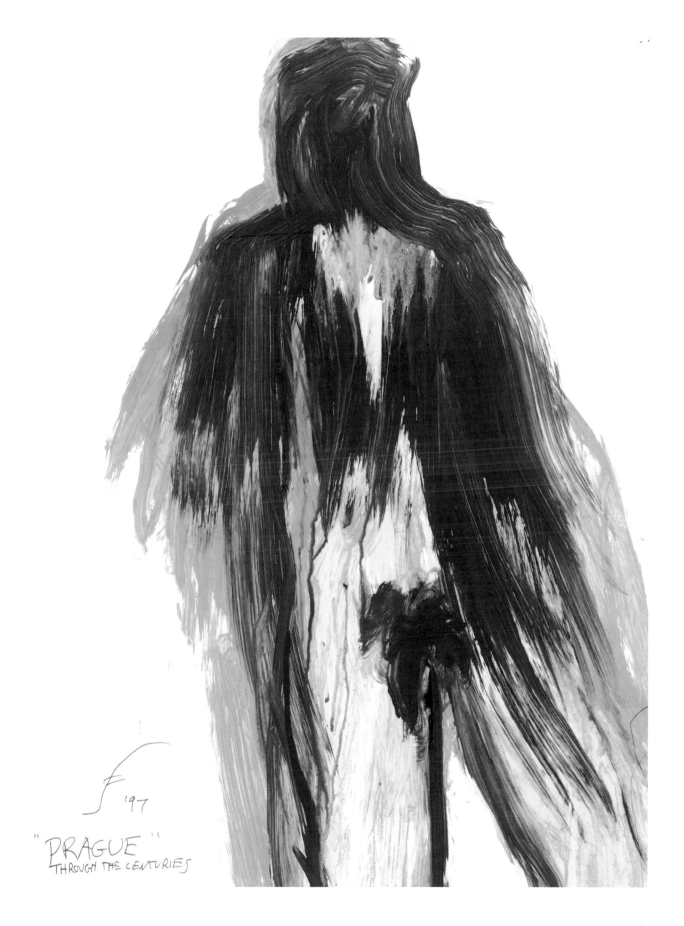

'97

"PRAGUE"
THROUGH THE CENTURIES

PRAGUE #2. 1998. Acrylic and Oil, 21½" X 30"

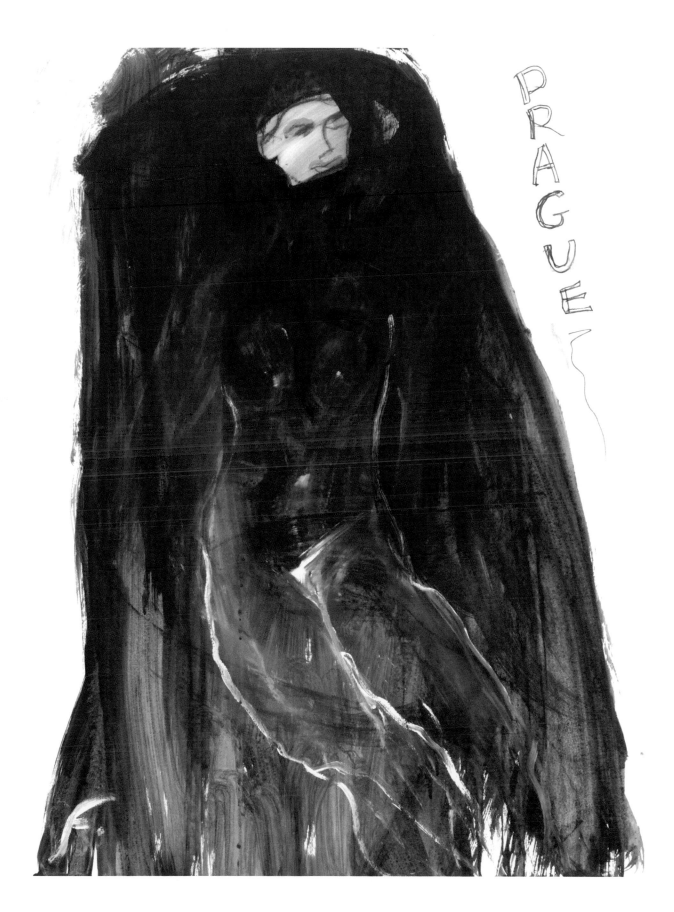

PRAGUE

BEHIND THE VEIL OF CANVAS. 1989. Acrylic and Charcoal, 21" X 22½"

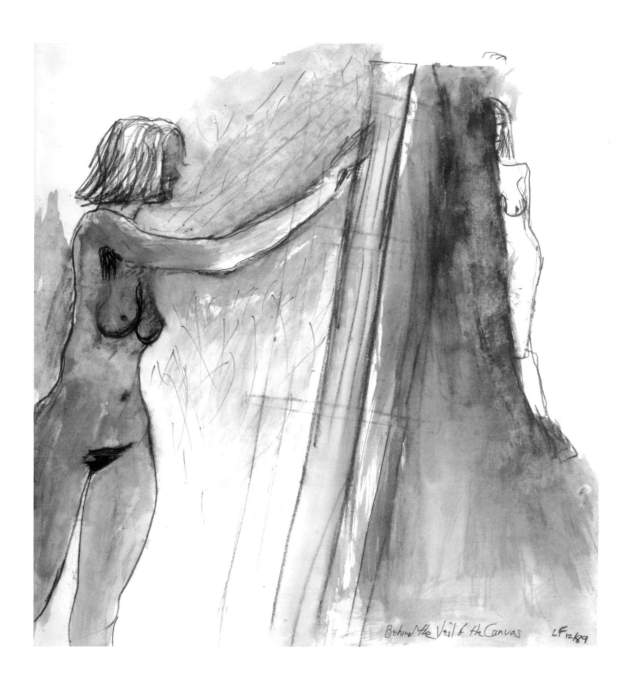

Behind the Veil of the Canvas LF 12/89

HOLOCAUST MADONNA. 1984. Acrylic, 23" X 28"

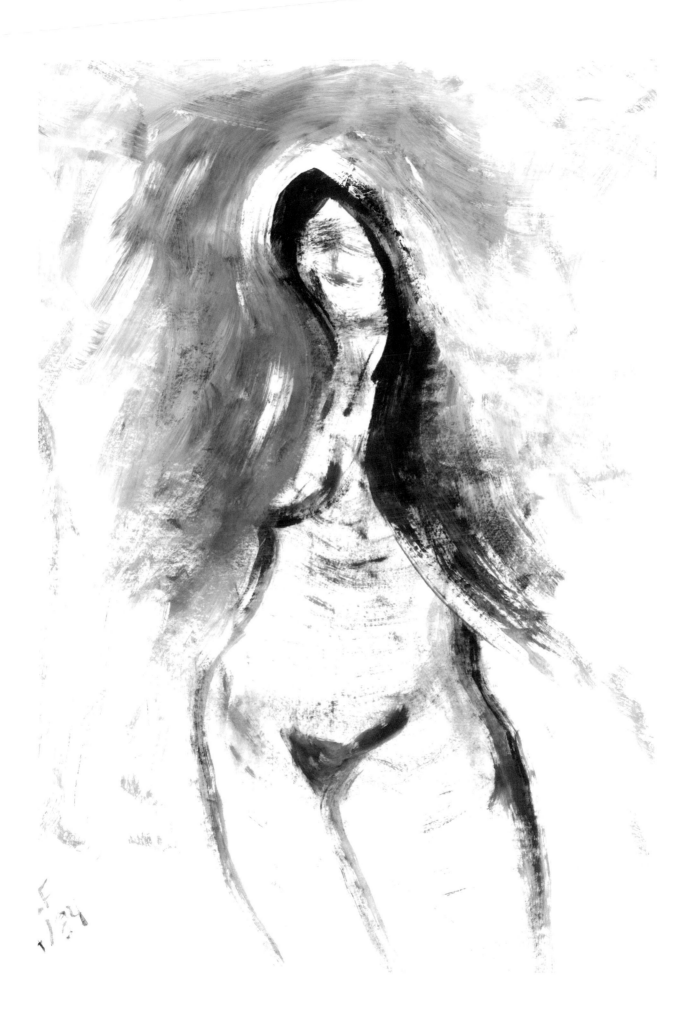

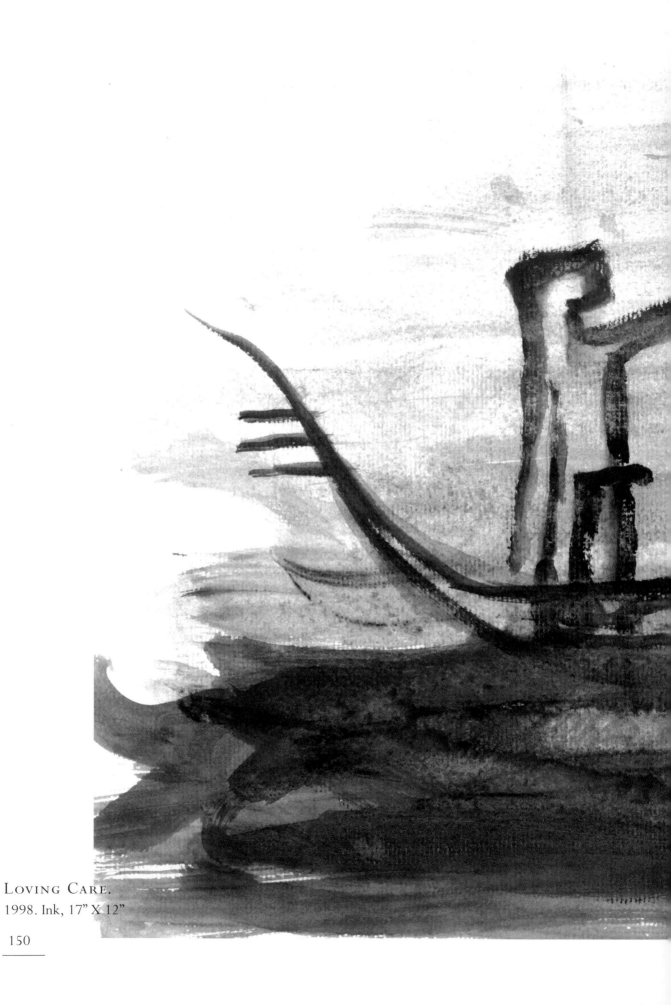

LOVING CARE.
1998. Ink, 17" X 12"

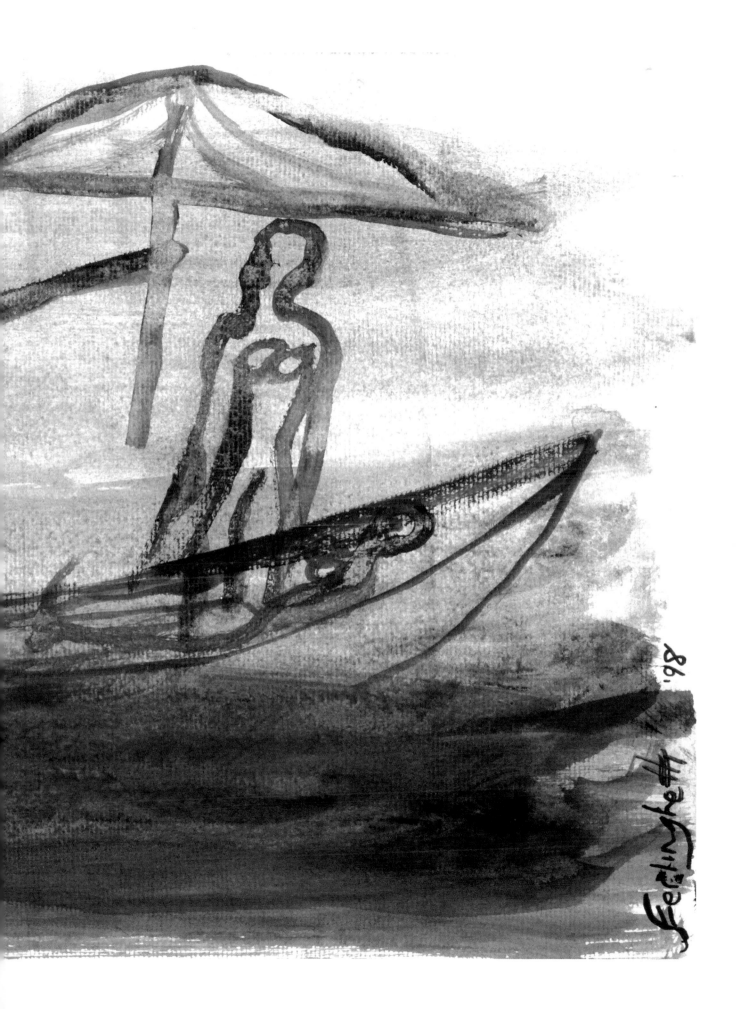

A Broken City in the Heart... 2003. Acrylic, 18¼" X 21½"

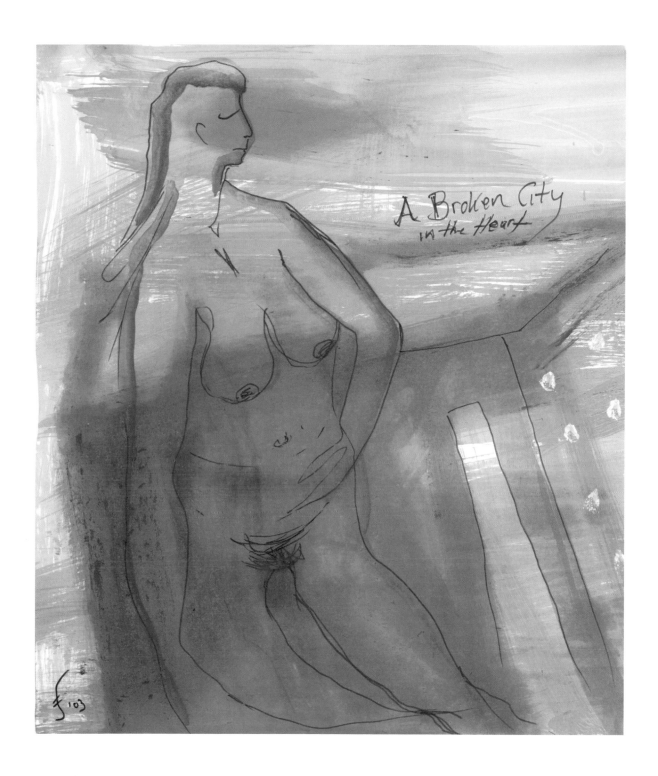

A Broken City
in the Heart

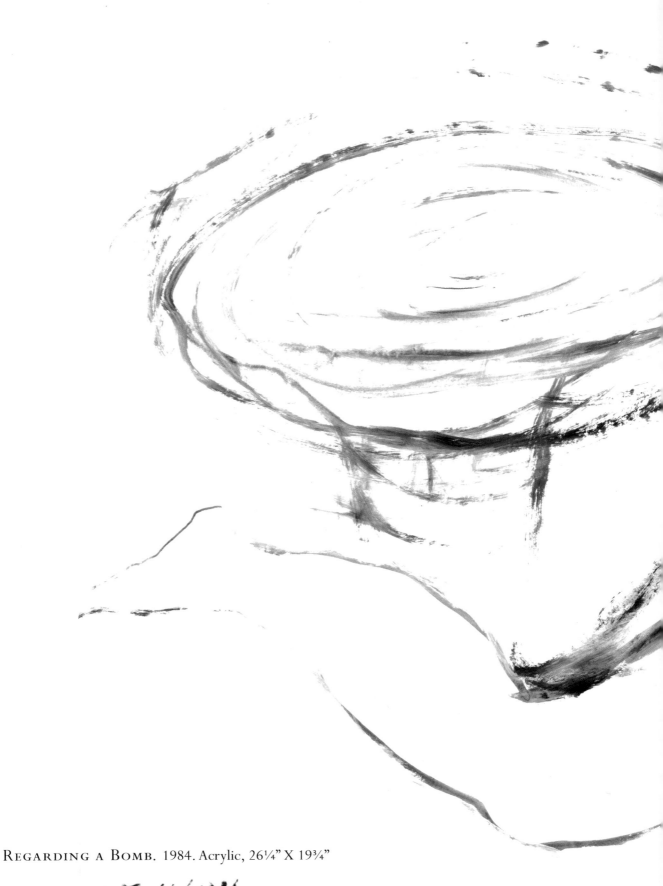

REGARDING A BOMB. 1984. Acrylic, 26¼" X 19¾"

LF 4/84

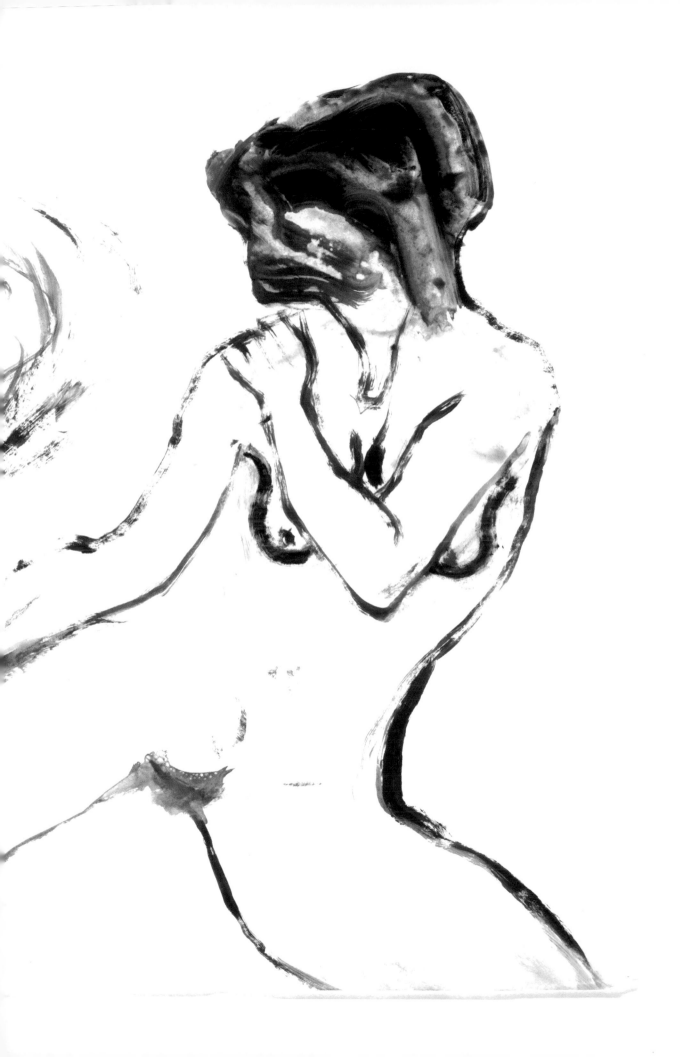

TEMPLE IDOL. 1996. Ink, 13½" X 16¾"

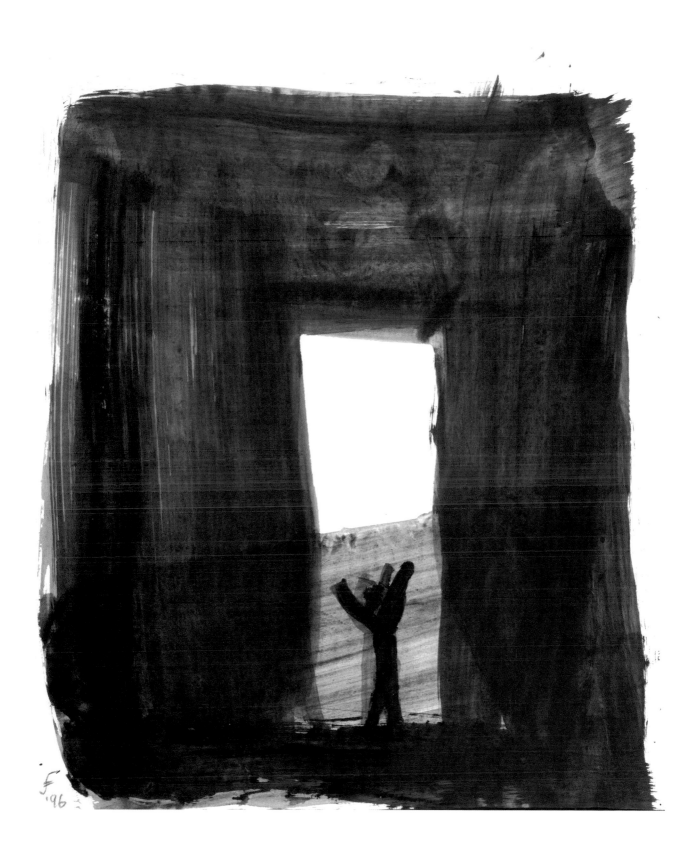

I Am the Door. 1980. Lithograph, 20" X 10"

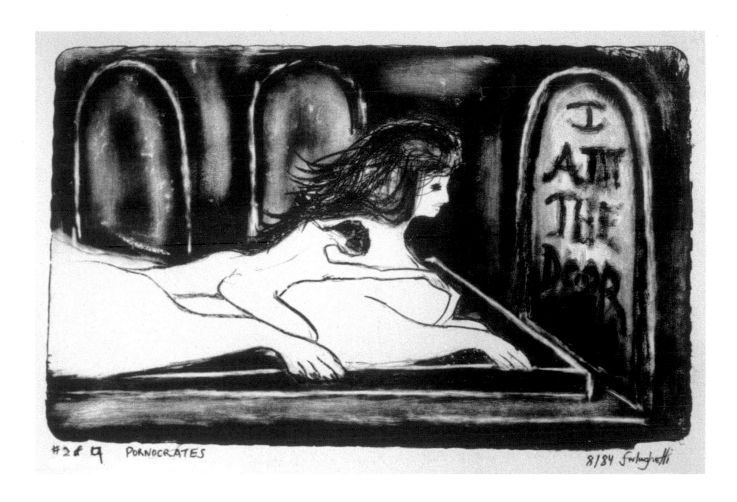

#28 q PORNOCRATES

8/84 Ferlinghetti

SING SING #1. 1990. Lithograph, 20" X 40"

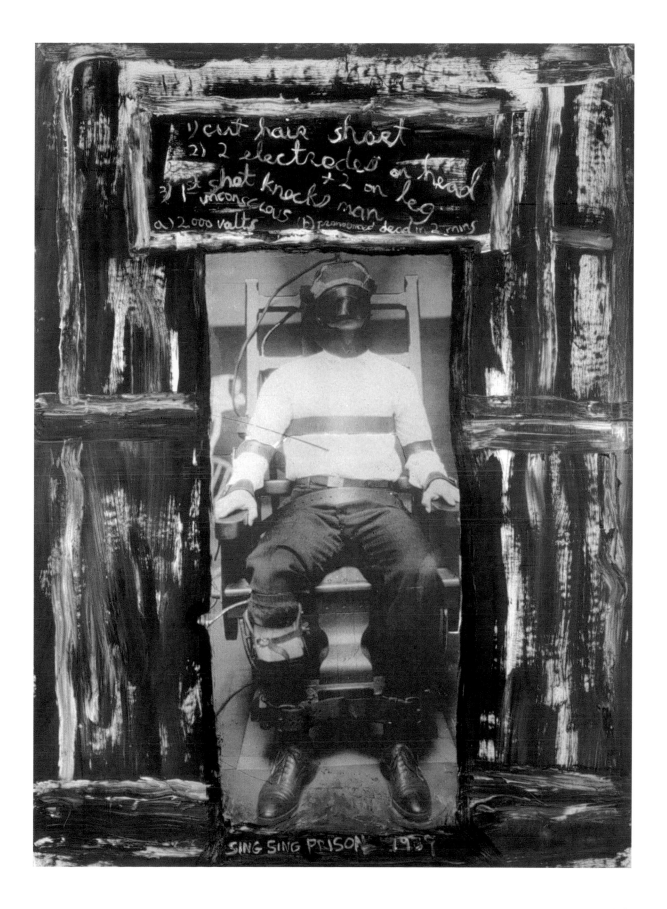

Policía, Oaxaca. 2002. Printer's Ink, 20¾" X 14¾"

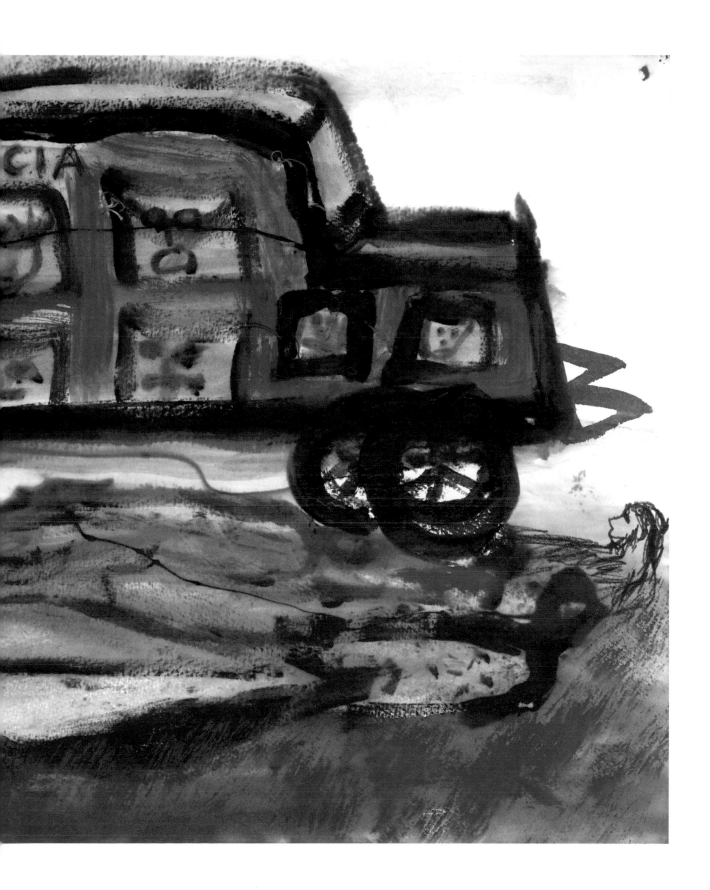

Por La Liberación de la Mujer, Oaxaca. 2002. Printers Ink, 20¾" X 14¾"

POR LA LIBERACIÓN

DE LA MUJER

Por La Liberación de la Mujer. 2002. Etching, 19½" X 12¾"

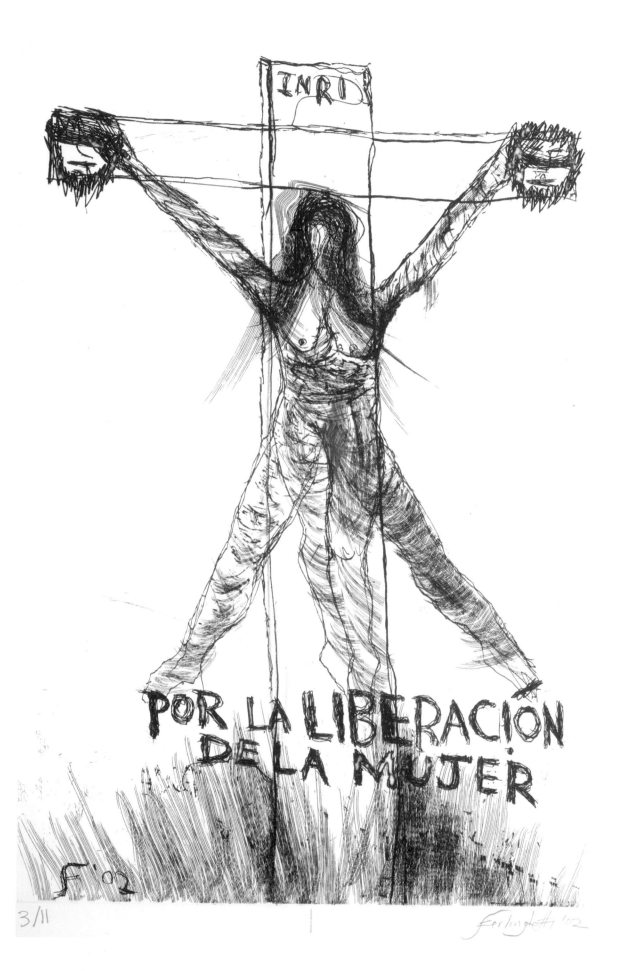

INRI

POR LA LIBERACIÓN
DE LA MUJER

3/11